IMAGES
of America

JACKSONVILLE
ILLINOIS
THE TRADITIONS CONTINUE

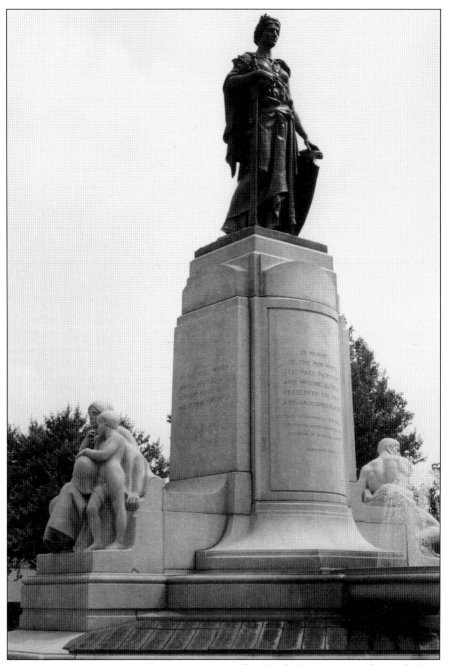

THE SOLDIERS' MONUMENT IN CENTRAL PARK. The Civil War Memorial was dedicated on November 8, 1920. Dr. C.H. Rammelkamp described the figures, as follows: "We hope the strong granite figure of Patriotism on the east answering the call to arms may strengthen us to answer every call to patriotic duty. We hope that the fine figure of Sacrifice on the west offering her choicest gifts to the great cause may inspire us to sacrifice on the altar of our country. We hope that the stately beauty of Columbia, crowning all and gazing in the direction in which the boys in '61 marched, typifying the spirit of America may call us all to a better, nobler citizenship."

IMAGES
of America

JACKSONVILLE
ILLINOIS
THE TRADITIONS CONTINUE

Betty Carlson Kay
and Gary Jack Barwick

ARCADIA
PUBLISHING

Published by Arcadia Publishing
Charleston SC, Chicago IL, Portsmouth NH, San Francisco CA

Printed in the United States of America

Library of Congress Catalog Card Number: 2008937373

For all general information contact Arcadia Publishing at:
Telephone 843-853-2070
Fax 843-853-0044
E-mail sales@arcadiapublishing.com
For customer service and orders:
Toll-Free 1-888-313-2665

Visit us on the Internet at www.arcadiapublishing.com

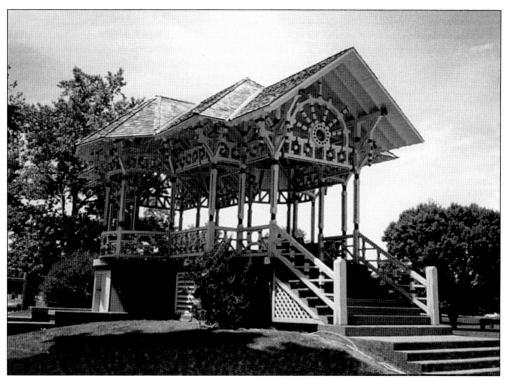

THE BANDSTAND IN COMMUNITY PARK. This is one of twin bandstands that were built between 1878 and 1879 on the grounds of the Jacksonville Mental Health and Developmental Center. The other bandstand was donated to the Smithsonian Institute for restoration and display, in 1983. The recently painted bandstand, pictured here, is still used for many occasions.

CONTENTS

ACKNOWLEDGMENTS

Anyone trying to write a history of a city like Jacksonville is naturally frustrated by the inability to contain, within the covers of any binder, the full story of this remarkable town and its talented citizens. So, see this book as it is intended: a compliment to those who chose Jacksonville as their home and as one of their priorities in life. Traditions surround us every day. Look for them and enjoy them. Then, pass on the traditions worth remembering.

"Thanks" is too small a word for the help given during the writing of this book. The Jacksonville Public Library has been generous in allowing me access to their files; institutions have welcomed me and given me a "behind the scenes" peek at their work; friends have allowed me into their homes to peruse their private photos and diaries; and my husband, John, was with me all the way. So, for all your help, support, and cheer, I thank you.

INTRODUCTION

Every family, every town, and every nation has traditions. They may grow purposefully at some times, while at other times, they seem to appear out of nothingness. A tradition may be as small as the way in which family members intentionally mispronounce a word in the exact same way that great-grandmother always did; or as large as the way a community welcomes those with special needs. Traditions are collective memory. They are glue holding one with another, and one with a community.

The history of Jacksonville, Illinois, is a collection of traditions. A very big small town, Jacksonville nurtures her traditions unconsciously. Delightfully renovated homes, physical growth at two colleges, strong support of voluntary organizations, and excellence in education, are some measures of the traditions, begun 175 years ago, that continue today.

In the year 2000, Jacksonville will celebrate the 175th anniversary of the town's beginnings. Back in 1825, arguments, as to which of several fledgling towns would become the county seat, were solved by platting a whole new town in the center of Morgan County. In so doing, Jacksonville was laid out in an orderly fashion, with dirt streets and a town square. Immediately, early pioneers filled Jacksonville with log cabins and optimism. They knew that this town was destined for greatness! With lots of hard work and very little money, they believed that prosperity could be brought to the fertile prairies of central Illinois.

And prosper they did. Citizens were so eager to establish an education plan and a college, that they began constructing the first college building, in 1829, before they actually had a faculty or students! Churches were built, railways were planned, and before long, stores and taverns were flourishing. The courthouse was built on the square, and 11 lawyers and 10 physicians were in practice by 1834. Since Illinois filled from the bottom up, with the majority of early settlers coming from southern states, there was a time when Jacksonville was the largest town in the state. (Chicago, in 1833 only had 150 people, not including the Potawatomi tribe, while Jacksonville, by 1834, was pushing 1,800 settlers.)

Dedicated pioneers worked to better their own lives and their community. Their efforts paid off in ways that were not always anticipated. A cholera epidemic in 1833, which, to some degree, affected an estimated half of the inhabitants of Jacksonville, could have defeated a less determined town. Although Jacksonville did not become the Illinois state capital, as some would have wanted (the cholera epidemic did nothing to enhance her chances), she continued her quest for prominence by acquiring the Illinois School for the Deaf, the School for the Visually Impaired, and the Mental Health and Developmental Center, all before 1850. Illinois

College, being the first of the important educational institutions in the town, was supportive in establishing other educational opportunities, which included the Jacksonville Female Academy, the Jacksonville Public Schools, the Whipple Academy, The Young Ladies' Athenæum, and the Illinois Conservatory of Music. In 1846, the Illinois Conference Female Academy (later the MacMurray College) was founded.

It was the people who came to Jacksonville and stayed during those early years that began the traditions we continue today. Frontier days were fluid times, with people moving on for reasons known only to them. In the census of 1860, only a little over 25 percent of the non-dependent population from the 1850 Jacksonville census could still be found. From 1860 to 1870, the years around the Civil War, only 21 percent of the population in Jacksonville could be traced. But it was the people who stayed, the ones who bet that Jacksonville had the greenest grass, who we remember in this book. They stayed to raise families, build up businesses, promote education, and live their lives.

As you read this book and enjoy the photographs, names of prominent Jacksonville forefathers and mothers will attract your attention as their physical images speak to you. Names that you knew only on street signs may suddenly become meaningful. Individuals may come back to life, if only for a brief moment.

While reflecting on the institutions and individuals that made Jacksonville what it is today, we think of the role of today's residents. There are those who bring to modern Jacksonville the same traditions of optimism and confidence that the early men and women shared. As earlier generations passed their traditions down to those that followed them, so will we pass on traditions to generations yet to come. Traditions of education, volunteerism, and a search for excellence continue, alive and well in Jacksonville at the turn of the 21st century.

One

THE TRADITIONS BEGIN

Before there was a town of Jacksonville, before there was a State of Illinois, and even before the Native Americans, there was the land. The wide, treeless prairies, with grass as tall as a man, were formed with the melting of the last ice age. To these prairies have come people of different cultures, but with a single aim, to live a prosperous, healthy, happy life. To this day, the land is one of the traditions that we take for granted. The fertile fields surrounding Jacksonville feed us and the world. To these unplowed fields came the first settlers, who became rooted to the fertile land and the possibilities of a fresh start.

The first men, whose names are recorded and remembered in this area, had been soldiers in the recent War of 1812, in which General Andrew Jackson of Tennessee became famous for his win at the Battle of New Orleans. Many towns became "Jacksonvilles" in the early 1800s. Colonel Seymour Kellogg, his brother Captain Elisha Kellogg, their families, and Charles Collins pitched camp on the north fork of the Mauvaiseterre River in 1819, after the Kickapoo Indians signed the treaty giving up their land in central Illinois.

By the time Jacksonville was platted with roads and a town square, the first resident, Alexander Cox, was joined by merchants Joseph Fairfield and George Hackett. The news of the rich Illinois soil was spreading, and it filled the area with settlers and anticipation.

And the traditions of looking forward with confidence continue today.

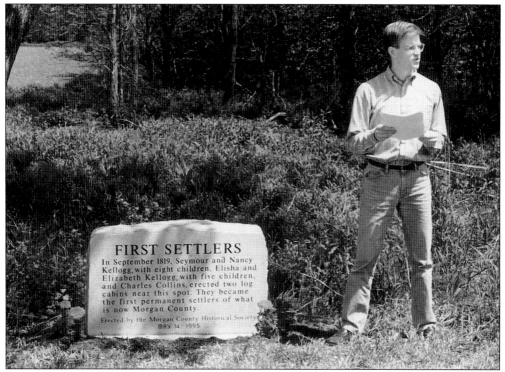

FIRST SETTLERS. In September of 1819, Colonel Seymour Kellogg, Captain Elisha Kellogg, along with their families, and Charles Collins became the first settlers in Morgan County, when they located their cabins on the north fork of Mauvaiseterre Creek. On May 14, 1995, the Morgan County Historical Society laid a marker at the site where Greg Olson spoke about the first settlers. The families came and then left Jacksonville rather quickly, supporting the notion that the lure to move to a "better" place was strong in the 1800s.

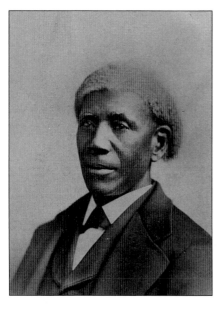

REVEREND A.W. JACKSON. Jacksonville could have been named for General Andrew Jackson, hero of the Battle of New Orleans, which took place two weeks after the War of 1812 ended. (Communication was slow in those days.) The town could also have been named for the Reverend A.W. Jackson, who told how, as a young slave in Jacksonville, he was sent to fetch some corn in Diamond Grove. He lost his way and asked some workmen for directions. They were laying out the new town and asked his name. When he told them "A.W. Jackson," they said the town would be named for him. The Reverend told that story all his life.

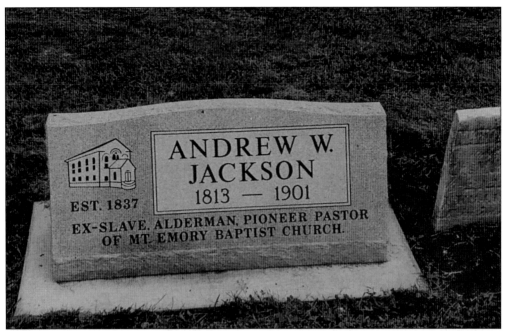

ANDREW W. JACKSON, 1813–1901. Recently, a fitting marker was belatedly etched in honor of Rev. Jackson. Starting out as a barber, he felt the call to preach, and prepared himself by his own study. He was the pastor of Mount Emory Baptist Church, founded in 1837, as well as being a city alderman.

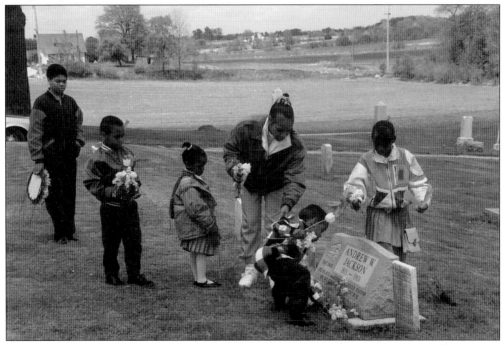

A TRIBUTE TO A.W. JACKSON. Children lay flowers on the grave of Rev. Jackson. The Morgan County Historical Society made the arrangements to have a fitting marker that commemorated his life.

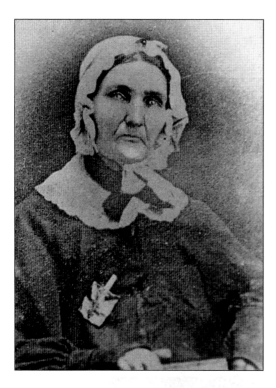

KATHERINE KENDALL CARSON, FIRST MIDWIFE, 1785–1869. The Carson family arrived in "Jacksonville " before it was known as such. Thomas Carson was the first tavern keeper, and he and Katherine helped promote the fledgling town. Katherine had great physical energy and mental ability. With nine children of her own, "Mother" Carson delivered over 3,500 babies, and also helped to run the inn with her husband.

MOTHER CARSON'S RECORD BOOK. Mrs. Carson purchased this slender record book from David Ayers, and in it she recorded the names of those she served as midwife. Hatch marks indicate subsequent births. One especially touching entry at the bottom of the page says, "Born to a stranger-in-the-grove, a child. I forget the name." Katherine had learned well from her doctor father the lessons of cleanliness and careful record keeping, and she rarely lost a patient. (Courtesy of Heritage Cultural Center.)

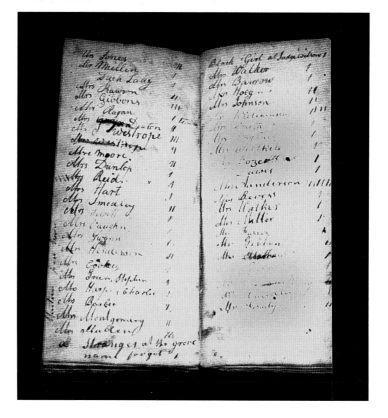

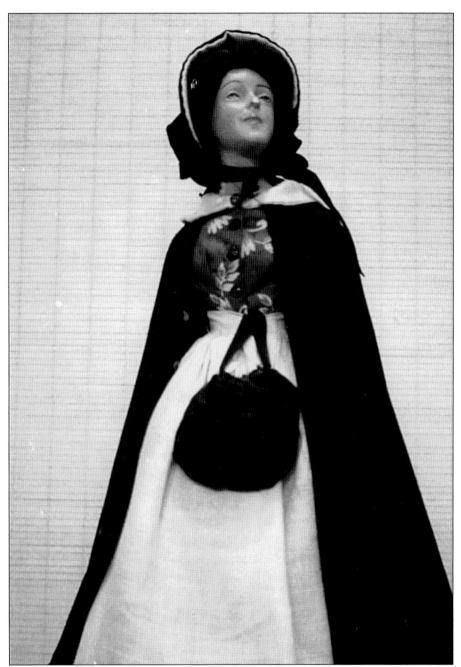

KATHERINE KENDALL CARSON DOLL. This doll of Katherine Kendall Carson is part of the collection of dolls, made by Janette C. Powell, in honor of Pioneer Women in Jacksonville. The collection of 12 dolls is displayed in the Governor Duncan Home. As a child, Katherine had gone on many house calls with her doctor father, who taught her the importance of cleanliness and of keeping written records. Katherine's energy and ability were legendary. When Katherine died in 1869, Judge Thomas said, "Nearly every old citizen can call to mind an occasion when her ready hand has ministered to their distresses and by her cheerful and encouraging demeanor sustained them in their trials." (Courtesy of Rev. James Caldwell Chapter NSDAR.)

13

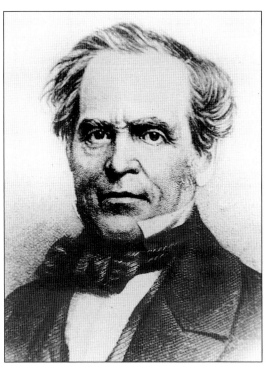

THE REVEREND MR. JOHN M. ELLIS.
Coming way out west to Illinois was a good decision for John Ellis. He met a sophisticated young woman of French descent in Kaskaskia, and she consented to be his wife. They were a popular couple in Jacksonville. Mrs. Ellis was known for her fine airs and good heart, and Mr. Ellis for his eagerness and zeal in starting Presbyterian churches and seminaries of higher learning.

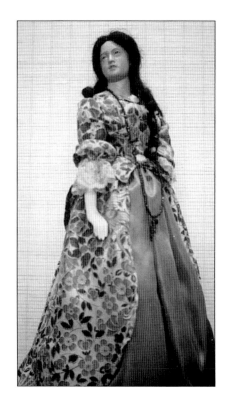

FRANCES BRARD ELLIS DOLL. While her husband, the Reverend John Ellis, concerned himself with establishing outposts of higher education for males in the Old Northwest, Mrs. Ellis was concerned about the education of females, so she began teaching and boarding young women in her home. This was the embryo for the Jacksonville Female Academy, which later became part of Illinois College. Mrs. Ellis also encouraged financial support for female students, a move that developed into the Ladies' Education Association. Unfortunately, she and her two daughters died in the cholera epidemic of 1833 while Mr. Ellis was away establishing Wabash College in Indiana. (Courtesy of the Reverend James Caldwell Chapter NSDAR.)

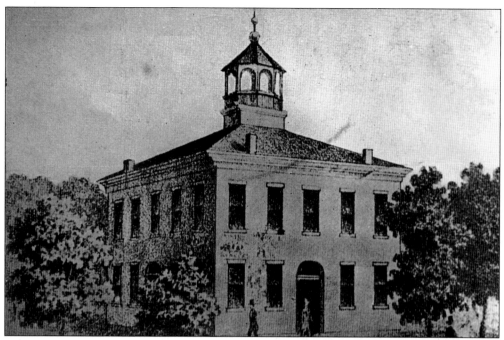

SECOND MORGAN COUNTY COURTHOUSE. The first courthouse was built of logs in 1825 when Jacksonville was platted. At that time, there were no trees on the plat and only one cabin, which belonged to Alexander Cox, a hatter. The second courthouse was built of bricks at a cost of $4,000.

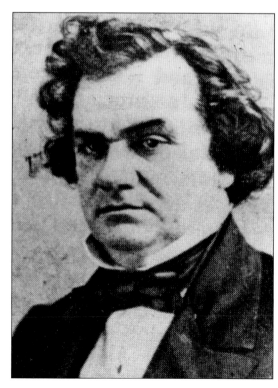

STEPHEN A DOUGLAS, 1813–1861. Stephen A. Douglas came to Jacksonville in November of 1833. He couldn't find a job, so he went to Winchester to teach. By March of 1834, Mr. Douglas was back in Jacksonville, where he was given the nickname, "The Little Giant." In 1835, he was selected as the state's attorney, and he was soon elected to the legislature. He was most famous for a series of debates around the state, with Abraham Lincoln, on the question of slavery. Douglas won re-election to the Senate, but Lincoln gained in popularity and later won the Presidency of the United States. Douglas died in Chicago in 1861.

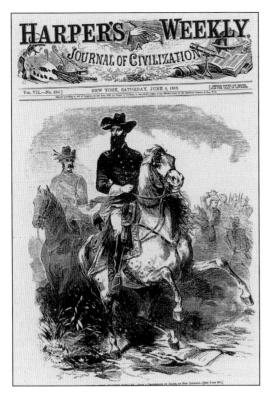

GENERAL BENJAMIN GRIERSON ON THE COVER OF *HARPER'S WEEKLY*. Some people surprise us with hidden talents. General Grierson fits that bill. He was a musician and band leader who disliked horses because one had kicked him in the head when he was a child. He wasn't particularly great in business, but when the Civil War was raging and there was a need, Grierson led his cavalry through the southern lines and cut off the confederate troops, allowing General Grant to cross the Mississippi River with his troops on his way to Vicksburg.

GENERAL BEN GRIERSON. When the Civil War ended, Grierson decided to stay in the army and lead a troop of black soldiers that were stationed in the Southwest. They were such a good unit that the Indians named them "Buffalo" soldiers, and, because of the general's pride in his men, General Grierson convinced the army to remove the name "Negro" from the name of the troop, changing it to just "The 10th Cavalry." Generals often took their wives with them on campaigns in those days, and Alice Grierson traveled with her husband for many years, far away from the comforts of home.

THE ELMS, HOME OF GOVERNOR DUNCAN, PIONEER IN EDUCATION. Governor Duncan was governor of Illinois when the state capital was in Vandalia. He was a great supporter of education. The first schools in Jacksonville were subscription schools, which means that individuals had to pay for their education. Anyone who gathered a few children together could call themselves a school teacher, with varying degrees of excellence. Governor Duncan worked, as early as 1823, to pass laws in support of common schools.

ELIZABETH SMITH DUNCAN, 1808–1876. Elizabeth Duncan met her husband-to-be, General Joseph Duncan, then the representative from Illinois, when President John Quincy Adams invited them both to dine at the White House. Elizabeth and Joseph married and moved to Illinois, where she graciously and generously lived the life of wife of the governor. The 12 Pioneer Women dolls are in the Governor Duncan Home. (Courtesy of DAR.)

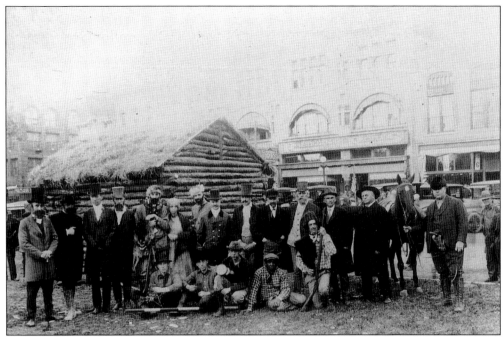

CELEBRATING THE JACKSONVILLE CENTENNIAL IN 1925. The Jacksonville Centennial was celebrated in many ways. In this photograph, men are dressed to reflect the styles of 1825. A log cabin was erected in the town square to recall the days of old as part of a re-enactment.

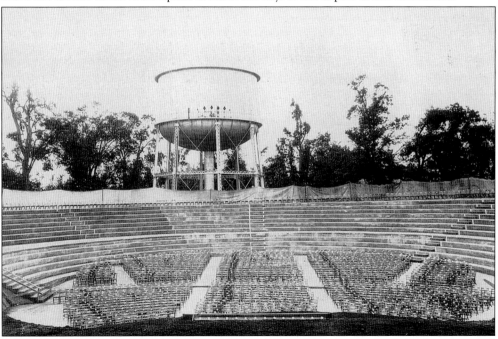

THE GREEK AMPHITHEATER IN 1925. This huge Greek amphitheater was built for the centennial celebration. Located in Veteran's Park, it was the site of many centennial productions. Since then, it fell into disuse and disrepair, as it developed a problem of standing water. The amphitheater was filled in and is just a memory today.

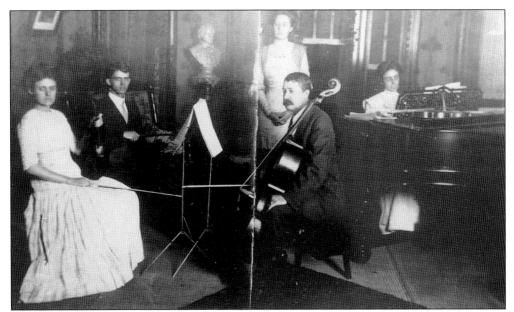

THE WILLIAM THOMAS BROWN FAMILY. William T. Brown owned a music shop on the square in the 1900s. The family would happily entertain themselves in their home in the evenings, in the pre-television era. The family included, Hazel, Howard, Susan, William Thomas, and his wife Anna.

THE GRAND HOTEL AND OPERA HOUSE. Early entertainment in Jacksonville might have also included evenings at the opera houses. They were not strictly formal opera houses, as we think of opera today. These houses were famous for bringing a wide variety of entertainment to a town which otherwise might feel isolated. Guest speakers, troupes of actors, musicians, *and Buffalo Bill's Wild West Show* came to either this opera house on Mauvaisterre and East Court Street, or to the Strawn Opera House on the southeast corner of South Main and the Square.

19

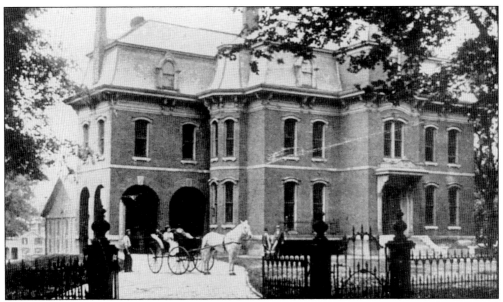

THE STRAWN HOME ON COLLEGE. Pictured here, in a wonderful photograph dating from around 1910, are Julius E. Strawn and his niece Henrietta A. Strawn. Soon after the picture was taken, dentist David G. Strawn donated the house to the Art Association of Jacksonville. This action fulfilled the wishes of his mother, Phebe Gates Strawn, who had built the home approximately 15 years after the death of her husband, Jacob.

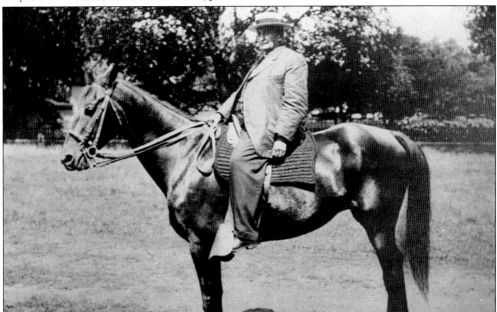

DR. DAVID G. STRAWN ON HORSEBACK. Jacob Strawn, the father of Dr. David G. Strawn, had come to Morgan County as a cattleman, and here he expanded his operation into a thriving business. During the Civil War, Jacob Strawn prospered, supplying beef to the Union Army and making large contributions to the Union cause. One of David's hobbies was raising racehorses, an activity that occupied his time after returning to Jacksonville with his nine-year-old son, upon the death of his wife.

Two

THE COLLEGES

The tradition of higher education in Jacksonville has its beginnings in ways that may seem like chance or destiny, while to others, it may seem like providence.

The tradition began in New England with John Millot Ellis, who came west to begin Presbyterian churches. He soon became even more interested in establishing institutions of higher learning, and when Mr. Ellis and Thomas Lippincott came upon Jacksonville, they thought that the hilltop was perfect. Additionally, the surroundings were beautiful, and the settlers were eager to proceed. The construction of the first building for the college (1829) was actually started before there was a faculty, or a student enrolled! As luck would have it, some soon-to-be graduates of Yale read about the endeavor and saw it as the answer to their own indecision about where to begin their life work. These seven young men have become known as The Yale Band. They came, they stayed, and their lives have become intertwined with the early history of Illinois College and the town of Jacksonville.

At almost the same time that Rev. Ellis was establishing Presbyterian churches and colleges, a Methodist preacher was also traveling here and establishing Methodist churches. Peter Cartwright lived in Pleasant Plains, and he was known for his extemporaneous preaching and his ability to convert people through emotional revivals. Though less enthusiastic about higher education than Rev. Ellis, Cartwright was supportive of the Illinois Conference Female Academy, agreeing to be president of the Board of Trustees in 1846. This is now the co-ed college that is named MacMurray.

And the traditions of excellence in higher education in Jacksonville continue today.

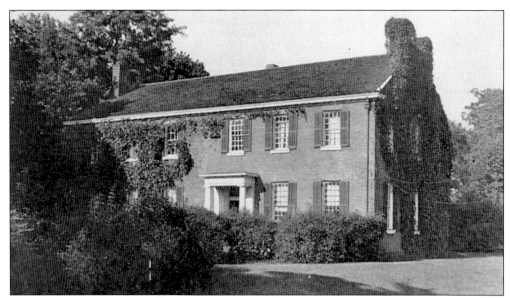

BEECHER HALL IN 1829. The first building in the state of Illinois at an institute of higher learning was begun in 1829, before money, a faculty, or students were assured. Named after the first president of Illinois College, Edward Beecher, it stands today as a treasured reminder of the past. The influence that the faculty of Illinois College had on the growth and development of the town of Jacksonville cannot be overestimated. Many faculty members became life long residents of the town, and they participated in civic as well as college affairs.

THE GATES OF ILLINOIS COLLEGE. Julian Sturtevant, the first teacher and second president of Illinois College, opened the college on a cold day in January of 1830 (after seeing to the fire), with the words "We are here today to open a fountain where future generations may drink." For 56 years, Mr. Sturtevant was a beloved teacher, who, like many others on the faculty, received very little pay for his work and sometimes even contributed his own funds to keep the college going. He became the second president of the college (1844–1876), and he lived as a symbol of the college to an old age.

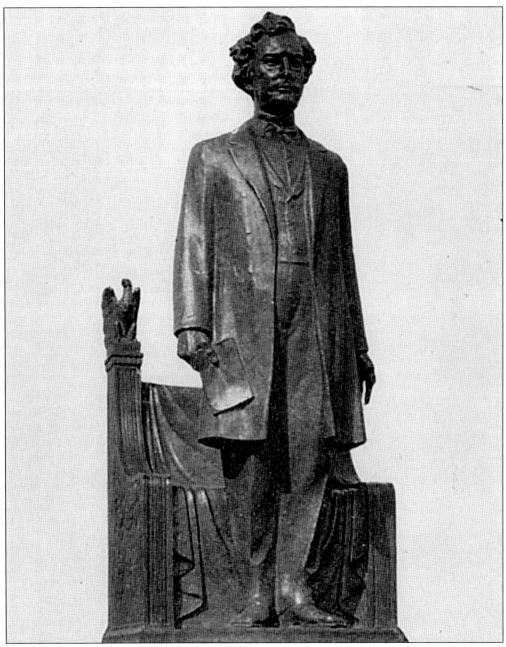

RICHARD YATES, FIRST GRADUATE, 1835. Born in 1818 in Kentucky, Richard Yates moved to Sangamon County in 1831. He attended Illinois College, graduating in 1835 as the first graduate of the college. He had a talent, from an early age, for giving speeches. He served in the state legislature, the U.S. Congress, and as governor of Illinois, running on the same ticket as his friend, Abraham Lincoln. He was famous as "The War Governor," and suffered for the soldiers and their families. But he was most proud of his attempts to pass universal suffrage laws. He did not live to see them passed, but his son, Richard Yates Jr., was able to vote for women's suffrage in 1919, fulfilling his father's dream of equal voting rights for women. This statue is on the grounds of the state capitol in Springfield.

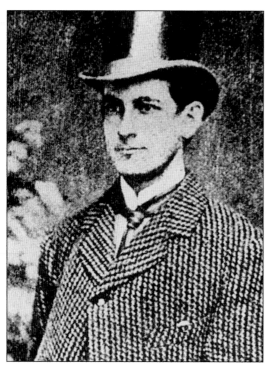

WILLIAM JENNINGS BRYAN, ILLINOIS COLLEGE GRADUATE. Mr. William Jennings Bryan is pictured here in his Junior hat. He began his preparatory studies at the Whipple Academy, and joined the freshman class two years later. Over time, he became an able speaker, winning prizes in oratory. He graduated in 1881 as valedictorian of his class.

WILLIAM JENNINGS BRYAN, THREE TIME CANDIDATE FOR PRESIDENT OF THE UNITED STATES. Mr. Bryan was the candidate of choice for the Democratic Party three times, in 1896, 1900, and 1908. His oratory skills were important to him throughout his life. Though he never became president, he was appointed secretary of state under President Wilson. His belief in a literal interpretation of the Bible led him to be the prosecuting lawyer against John Scopes, the teacher who was accused of teaching evolution in the Tennessee public schools. Bryan won the case, but he died shortly afterwards.

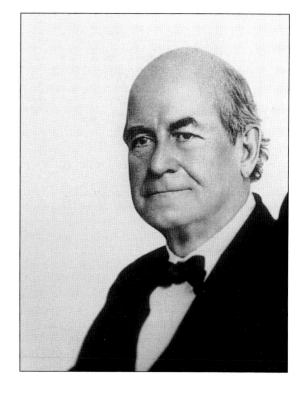

THE GYMNASIUM AT ILLINOIS COLLEGE. Pictured in the 1895 yearbook, Rig Veda, is the old gymnasium. The annual gymnasium contest is described in turn of the century prose, such as, "The College Band in the balcony safely out of reach, played 'I Dreamt that I Dwelt in Marble Halls,' to bring the minds of the spectators into harmony with the spirit of the occasion. The 'Herculeses' and 'Ajaxes' were taking off their collars and combing their hair back so as to look wild and fierce."

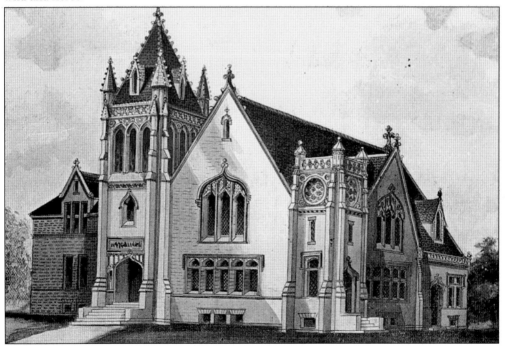

JONES MEMORIAL BUILDING. In 1895, when the college needed to expand its library facilities, a generous alumnus, Dr. Hiram K. Jones, donated the seed money to establish it in the name of his wife, Elizabeth Orr Jones. The cornerstone was laid in the fall, and in June it was dedicated. The donation improved the library facilities, added recitation rooms, and provided a chapel.

WHIPPLE ACADEMY. Early education was inconsistent on the prairies of Illinois, and often a young man would come to Illinois College ill-prepared for college level courses. Whipple Academy was formed as a preparatory school for young men, who would often spend a year or two in the academy before entering the college. The academy was at Kosciusko and Morgan, but this building was erected on the college campus as Whipple Academy in 1882.

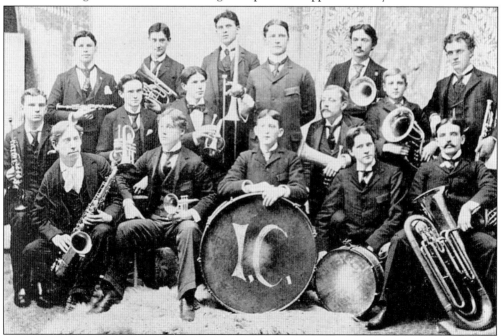

THE ILLINOIS COLLEGE BAND. Pictured here, in the 1895 Rig Veda Yearbook, is the Illinois College Band, which was organized in 1893. In the front row, on the bass drum, is W.C. Lurton, and on the euphonium is F.G. Carriel. Their Rig Veda March was respectfully dedicated to President Bradley and his wife.

GRADUATION DAY 1935. Long before Rammelkamp Chapel was built, graduation ceremonies were held in nearby locations, including Westminster Presbyterian Church (now First Presbyterian Church). Shown here is Walter B. Meyer, who graduated in June 1935 with a degree in Chemistry. Less than 24 hours later, he quite fortunately landed a job at the Museum of Science and Industry, Chicago.

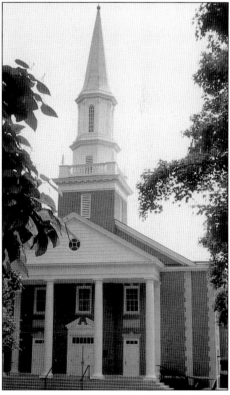

RAMMELKAMP CHAPEL. In 1905, when C.H. Rammelkamp was asked to undertake the presidency of Illinois College, he was flattered, but aware of the difficult road ahead. Finances were a problem, but under his leadership, the college weathered WW I and found itself in a better financial situation. The chapel proudly bears the name of this Illinois College president.

JACKSONVILLE FEMALE ACADEMY, JUNIOR CLASS, 1897. While the young men were attending Illinois College, the young women of Jacksonville were not content to be uneducated. Few colleges at the time invited women to attend (Oberlin in Ohio being the first to graduate a woman in 1841). Jacksonville women and men worked together to open schools for women, and the most notable of these was "The Jacksonville Female Academy." It opened on May 22, 1833, with an enrollment of 31 pupils. The teacher and principal in charge was Miss Sarah C. Crocker of New Hampshire. The academy was "the earliest school for the exclusive education of women in all the vast territory covered by the ordinance of 1787." After the passage of many years, the academy and Illinois College merged in 1903 for the betterment of all involved.

JACKSONVILLE FEMALE ACADEMY , SENIOR CLASS, 1897. In the yearbook for 1897, *Town and Gown*, there is a history of the Jacksonville Female Academy, in which complete credit for its founding is given to "men whose names hold a conspicuous place in the work of establishing schools and churches." It is hard to believe that, even in 1897, women were given no credit for their part in the undertaking. The founding mothers also deserve our long overdue respect. On a lighter note, there was a reminder of the school's general rules in the same volume. One rule in particular states that, "Pupils will not recognize parties from their windows, nor communicate with gentlemen on the street, nor with persons in the city by correspondence." This was the first annual ever produced by the Jacksonville Female Academy.

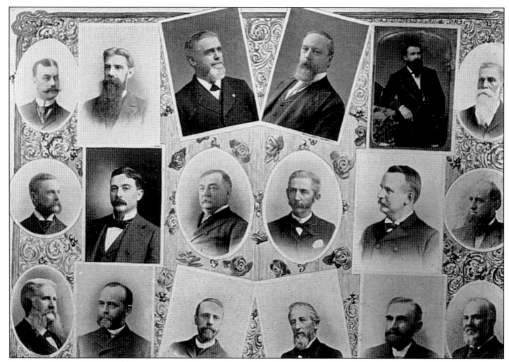

TRUSTEES OF ILLINOIS COLLEGE, 1895. This photograph of the trustees of Illinois College is in the Rig Veda Yearbook for 1895. The Jacksonville names include, the Honorable Edward P. Kirby; Julius E. Strawn; Lloyd W. Brown; Marshall P. Ayers; Thomas J. Pitner, M.D.; Ensley Moore; and Henry F. Carriel, M.D.

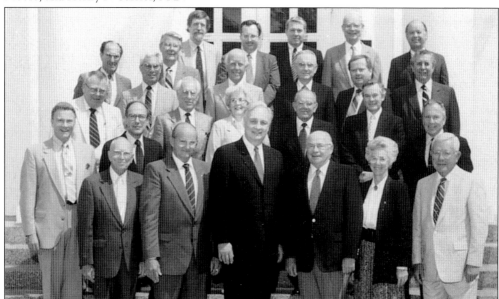

TRUSTEES OF ILLINOIS COLLEGE, 1988. Women began attending Illinois College in 1903, and in 1928, Dr. Grace Dewey was a trustee of Illinois College. Pictured in the front row of the 1988 Board of Trustees is Carol Lohman, who served 25 years and was vice-chairman of the board for several years. In the second row is Anita Rundquist.

PETER CARTWRIGHT, METHODIST PREACHER AND TRUSTEE OF ILLINOIS CONFERENCE FEMALE ACADEMY. Though Peter Cartwright was a zealous, circuit-riding preacher, who at times was known to ridicule education, he became a strong supporter of women's education here in Jacksonville after witnessing the success of an academy that had opened in Cincinnati. He became the first president of the Board of Trustees. In 1851 the name of the academy became the Illinois Conference Female College, in 1863 it became the Illinois Female College, and then in 1930, the MacMurray College for Women.

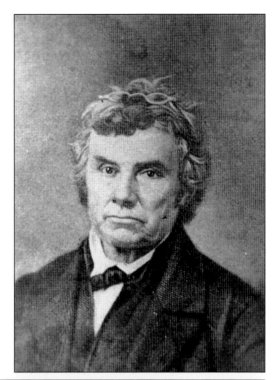

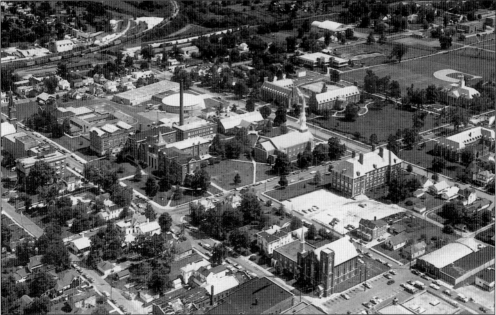

AERIAL VIEW OF MACMURRAY COLLEGE. This recent aerial view shows MacMurray College as a modern, coed facility. Named for its wealthy benefactor, James E. MacMurray, who donated approximately $4.5 million, the college has benefited from the MacMurray family's generosity, which began when their daughter was a student. Mr. MacMurray, a "captain of industry," humbly said that "MacMurray College has been more to me than I have to the College."

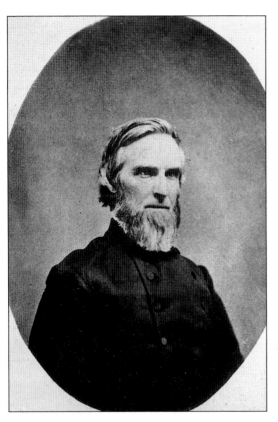

JAMES FRAZIER JAQUESS, FIRST PRESIDENT. Mr. Jaquess came to the Illinois Conference Female Academy, tightened up its academic requirements, and left, seven years later, calling it the Illinois Conference Female Academy and College. He was president in the golden age of antebellum education. Buildings were built, a good faculty was retained, and the school grew in size.

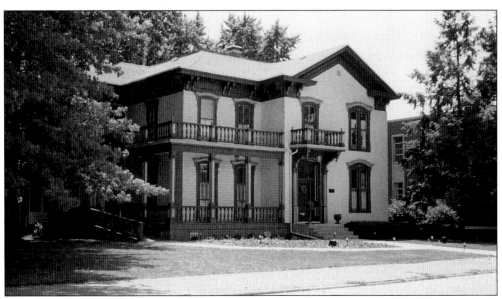

THE PRESIDENT'S HOUSE, 339 EAST STATE STREET. The MacMurray president's house was built between 1848 and 1853 by Captain John Henry. MacMurray acquired the building in 1925 and used it as a dormitory for women. In 1929 it became the president's home. Recent colorful paint on the exterior is delightful to see and in keeping with its historical accuracy.

SENATOR JAMES E. MACMURRAY. James E. MacMurray, a one-time senator from Illinois, had prospered with the ACME Steel Corporation in Chicago. His daughter Miriam attended the Illinois Women's College, and the senator was inspired to contribute millions to the college. In 1930, the college was named in his honor. He became good friends with President McClelland, and the two "Macs" were often photographed together.

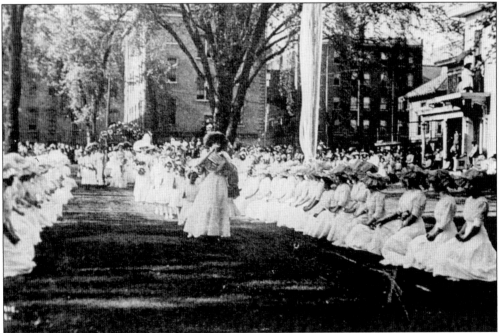

MAY CELEBRATIONS AT MACMURRAY. The first mention of a May Day party at the college was in 1899. "The Senior Preparatory Class crowned their class officer, Miss Carrie Elizabeth Line, queen of May and wound their class colors around the pole." (*A History of MacMurray College,* Watters.) Later, the event was enlivened with elaborate performances, pantomimes, and stunts by the different classes. The pageant was considered part of physical education.

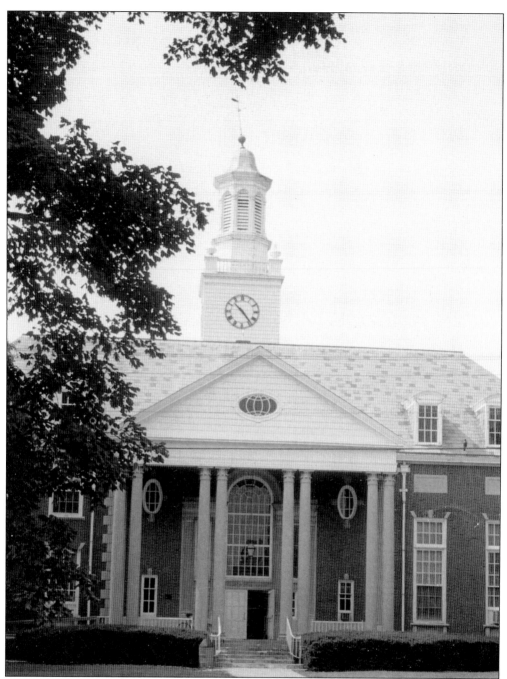

THE HENRY PFEIFFER LIBRARY, 1941. The old library in Main Hall was crowded and outdated. Enter Mrs. Annie Merner Pfeiffer, whose generous donation to build a new library was matched by the college. On moving-in day, May 17, 1941, streets were closed, and the faculty and students (singing all the way) set about to move the books to the new building, on a well-orchestrated route. On May 24, 1941, Mrs. Annie Merner Pfeiffer visited the campus for the first time, and she formally presented the library in memory of her husband.

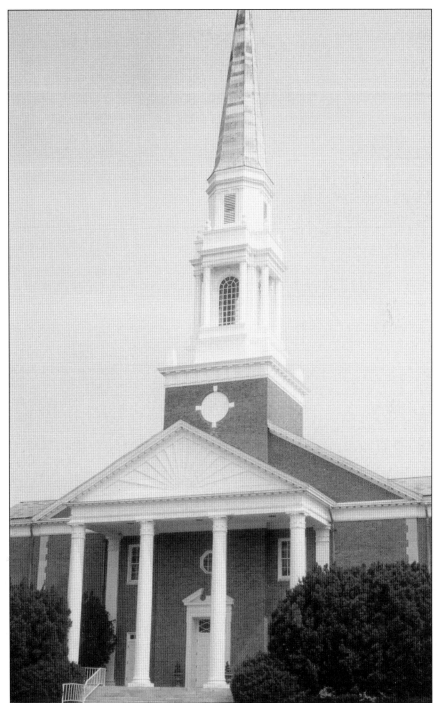

ANNIE MERNER CHAPEL. In 1944, Mrs. Annie Merner Pfeiffer generously agreed to donate money for a chapel, if the friends of the college would match her gift. It was accomplished, and today the chapel and the library face each other as Annie Merner desired. Tradition has it that this loving couple wished for nothing to be built between them to obstruct their view of each other into perpetuity.

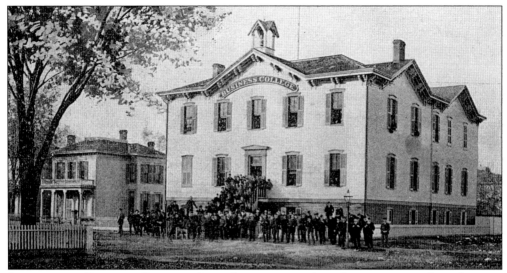

JACKSONVILLE BUSINESS COLLEGE. A need was expressed in the community for a business college, and in May of 1866, Professor Rufus C. Crampton, of Illinois College, founded the Jacksonville Business College. At first, it was located on the north side of the public square, then it was moved into the Whipple Academy, and controlled by Illinois College. In 1876, Professor George W. Brown purchased the institution, the building and the grounds.

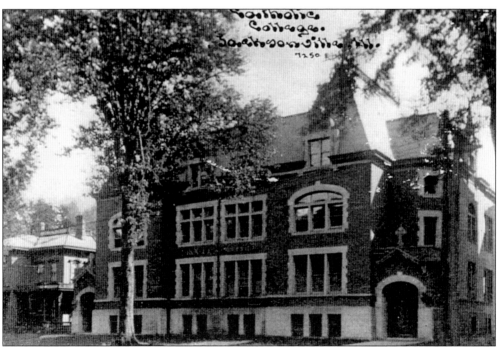

ROUTT COLLEGE, 1905. Routt College, a Catholic institution, was located on East State Street. The college was founded by William R. Routt and his son, Harvey J. Routt, who gave a $25,000 contribution and the land on which to build. Catholic and non-Catholic friends also donated money. When the building was dedicated, William Routt contributed an additional $50,000. The college opened in September of 1905.

Three

THE STATE INSTITUTIONS

In 1842, when Illinois College opened the first medical school in the state, another tradition entered Jacksonville along with the medical students and faculty, which was caring in the most scientific way for people with special needs. Three major institutions were eventually founded. The first was the School for the Deaf, which had 13 pupils by 1846. The second, the Mental Health and Developmental Center, was desperately needed, but the state was overextended financially, and the people of Jacksonville had little ready cash to undertake another school. It took the extra push from one of the interested citizens, J.O. King, who convinced Dorothea Dix (already famous for her work securing better living conditions for those with special needs) that an immediate visit to Illinois was imperative. After touring and working with the legislature, the Dix-Constable bill passed, and Jacksonville was the home of her second institution.

Before the State Hospital for the Insane was a sure thing, progress was being made to acquire a school for the blind. Joseph Bacon, a blind teacher, was invited to open a private school for the blind. It opened with six students, and was supported by fees and private donations. This small, private beginning was all that was needed to convince the state legislature that Jacksonville should also secure the state School for the Visually Impaired, since the embryo for such a school was already in existence.

And so the tradition of supporting benevolent institutions began early and continues today.

MAIN DRIVE TO THE SCHOOL FOR THE DEAF. "The character and the ideals of any community are reflected in the institutions which the people of that community seek and support." (Carl E. Black, M.D.) The first state institution to be located in Jacksonville was the School for the Deaf, after the citizens of Jacksonville purchased 6 acres of land for the school on the west edge of the city. Note the straight drive to the front door, which is now replaced with a user-friendly circular drive.

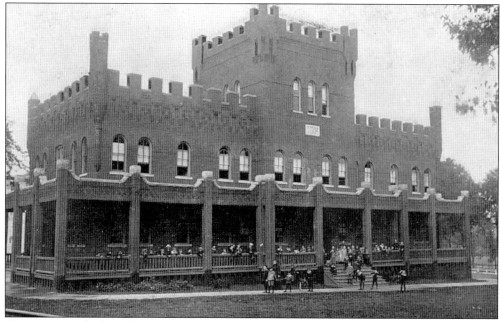

THE CASTLE. The boys' dormitory at the School for the Deaf gave every appearance of a castle. The number of buildings required for the state institutions has continued to change, sometimes including demolishing as well as building. Renovation has also been important, and the foyer of the main building of the school has recently been elegantly restored.

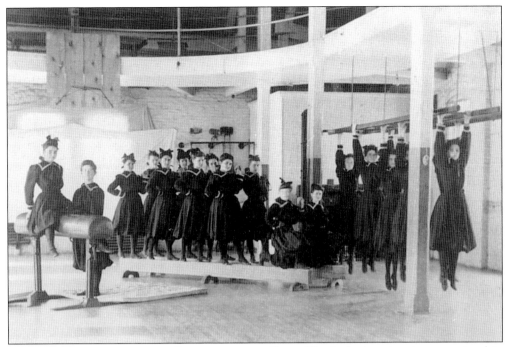

PHYSICAL EDUCATION AT THE SCHOOL FOR THE DEAF. Physical education is not omitted in the curriculum of this school. Today, teams compete in many sports from football, to track, to wrestling. Here, the girls are exercising in state-of-the-art gym attire for the turn of the century.

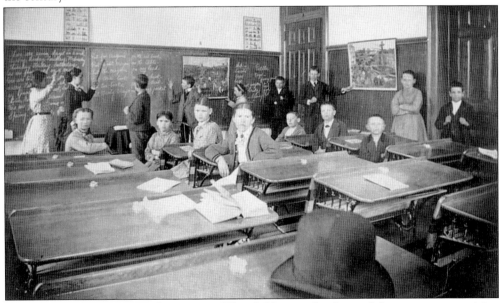

AN EARLY SIGN LANGUAGE CLASSROOM. The children at the front of the room are practicing signing the phrases on the blackboard. They use repetitive language to reinforce the signs. "Put five crayons on the red book. Put eight crayons on the table. Put ten crayons on my head." This is not unlike the drills used in the acquisition of any new language. Note the derby hat in the forefront of the picture.

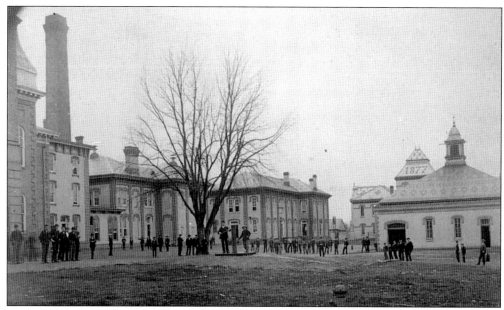

RECESS. Enjoying a few moments outside are groups of boys tossing a ball, pumping themselves a drink, and "hanging out." The School for the Deaf was almost a town of its own with its many buildings, which provided many services for the school community. Central courtyards, such as this one, provided room to break between classes and after school.

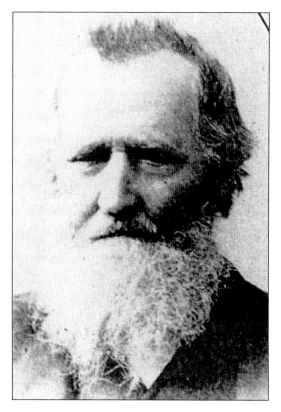

SAMUEL BACON, FIRST SUPERINTENDENT OF THE INSTITUTION FOR THE EDUCATION OF THE BLIND. When Samuel Bacon arrived in Jacksonville, in 1847, at the age of 24, he was under the impression that a school for the blind was being built. Unfortunately, it was the hospital for the mentally ill that was under construction. Not one to be deterred, he chose to stay in Jacksonville and help establish the Institution for the Education of the Blind, which is now known as the Illinois School for the Visually Impaired (ISVI.)

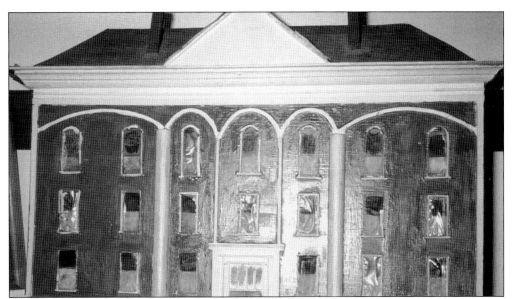

ILLINOIS INSTITUTION FOR THE BLIND, AS IT APPEARED IN 1853. The Illinois School for the Visually Impaired celebrated 150 years of service in 1999. During these years, proper education for the blind has taken many shapes. For years, learning a trade was stressed. But the field of education caught up with what many of the blind already knew, and a better balance was struck between a general education and a trade school. Together, the school became a quality educational center. Pictured is a student's model of the school in 1853.

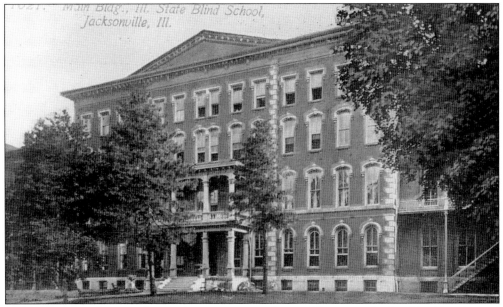

MAIN BUILDING, ILLINOIS STATE SCHOOL FOR THE BLIND. The original school building burned in a fire on April 21, 1869. The students were safe, and classes resumed in what had been Berean College. Miss Eliza Ayers had purchased the property with an eye to opening an orphanage there, but she made it accessible for the immediate needs of the school for the blind. The west wing of this new building was built to replace the first edifice. Then, the middle portion was built in 1874. The east wing was completed in 1882.

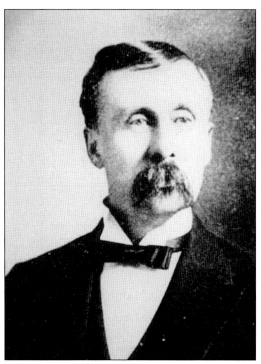

FRANK H. HALL, SUPERINTENDENT AND INVENTOR. In 1890, Frank Haven Hall was hired as superintendent of the School for the Blind because he was a good administrator and teacher. He was also an inventor, and he quickly saw the need for a better system of writing for the blind. Many people on the cutting edge of technology were working on an invention of this sort at approximately the same time, but Hall's machine was found to be most favorable.

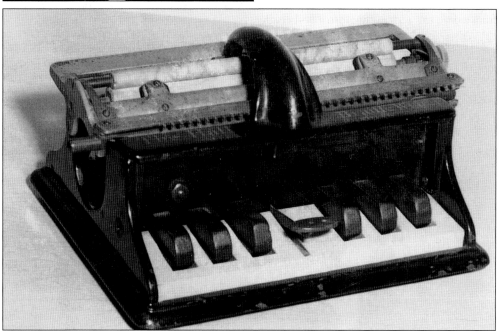

THE FIRST HALL BRAILLE WRITER, 1892. Frank H. Hall helped open the world to the blind, with the invention of the Braille Writer. Technical design and actual production were provided by Gustav Sieber, who owned a gun shop at 213 East Court Street. The writer has six keys for the six dots in each cell, and a space key to move on to the next cell. Mr. Hall also invented the Stereotype machine, for use in the printing of Braille music and books, as well as a map-making machine.

BASKETRY, 1940. Basketry was much more than basket making, at the school for the visually impaired. The high-quality basketry, pictured here, shows real talent in many forms of furniture, from a desk to a rocking chair to a doll cradle.

HAMMOCK MAKING. Knickers and high-top shoes infer the year that this picture was taken. Hammock making was a popular skill. Many sighted people would find knotting a hammock a challenging enterprise. At one time, students at the School for the Blind did the knotting with skill and relative ease.

ALICE S. RHOADS, DAUGHTER OF DR. JOSHUA RHOADS, C. 1870. Alice Rhoads taught music at the School for the Blind. She also established the Joshua Rhoads Memorial Library at the Congregational Church.

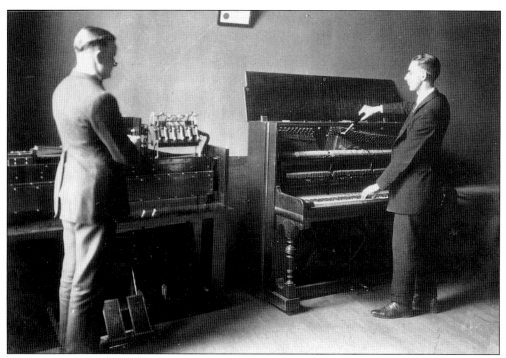

PIANO TUNING. Musical talent manifests itself in many ways. Piano tuning was taught at the School for the Blind (now ISVI). This activity combined a musical aptitude with a profitable employment opportunity.

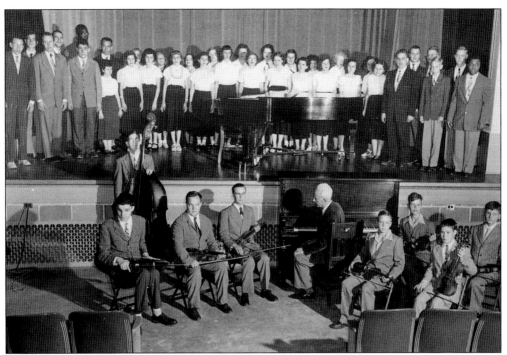

ORCHESTRA AND GLEE CLUB, 1951. A musical presentation, complete with its own orchestra, was a big event in 1951. Frank G. Meyers is pictured at the piano.

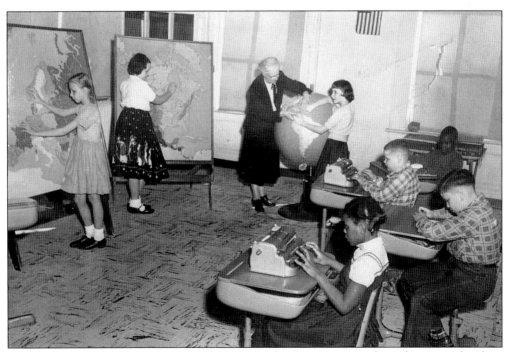

FOURTH GRADE GEOGRAPHY CLASS, 1957. Miss Helen Sweeney is teaching the geography class. Frank Hall invented a Braille map-making machine, at the turn of the century, which would have been well used in this class.

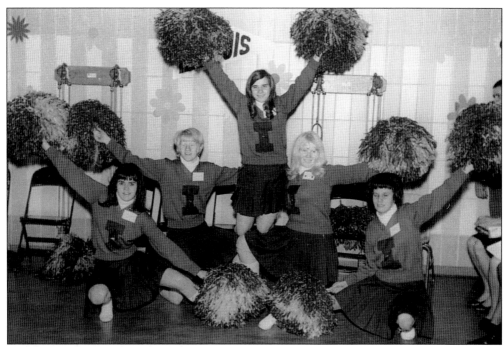

CHEERLEADING AT ISVI. Pictured here, leading a cheer at a 1970 conference, are, Debbie Reed, Judy Sepich (Thompson), Patty Knight, Debbie Newman, and Penny Kempf. (LeAnn Mayne was absent from the picture.)

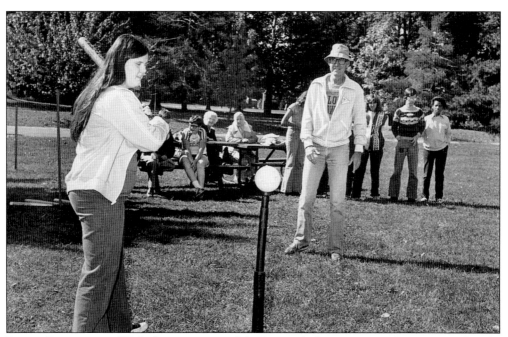

BEEPER BALL, 1970. With the invention of the beeper ball, many sports became a reality for the visually impaired athlete. The batter is Roberta Chappell, and Bill Oldenettel is fielding.

EDWARD MEAD, M.D., PIONEER NEUROPSYCHIATRIST OF ILLINOIS. Dr. Edward Mead accepted the Chair of Medicine at the Illinois College School of Medicine in 1845. Here in Jacksonville, he found serious plans afoot for securing an institution for the insane. Perhaps a factor that enhanced his candidacy was his interest in the care and treatment of the mentally ill. He was prolific in his letter writing in support of such an institution. With his help, Jacksonville acquired the Illinois State Hospital for the Insane. Following this success, Mead moved on and opened a private institution in Chicago.

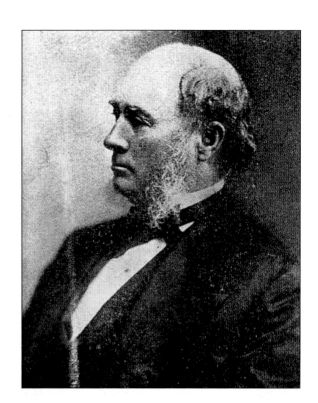

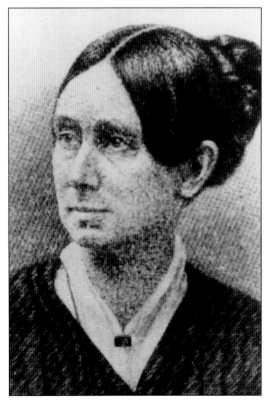

MISS DOROTHEA LYNDE DIX VISITED JACKSONVILLE. Miss Dix was well known in the east for her campaigns for better care of the insane, the deaf, and the blind. J.O. King wrote to her and impressed upon her the need for her able assistance in Illinois. He convinced her to change her schedule, and she toured Illinois in the spring of 1846. With her help, the citizens of Jacksonville accomplished their goal of a second state institution.

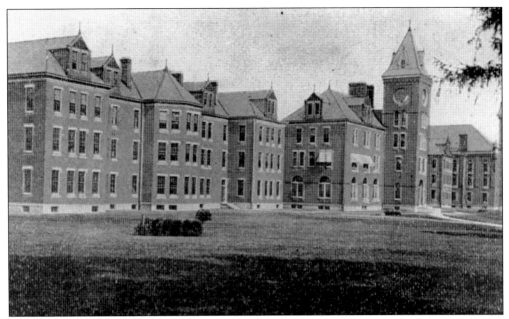

THE STATE INSTITUTION FOR THE INSANE. The first patient arrived at this hospital in 1851. The institution then saw phenomenal growth. Covering over 150 acres, it had its own heating plant, carpenter shop, conservatory, stables, and all its own kitchen, dining, and laundry facilities. With changing laws regarding the best way to care for the mentally ill, the facility has decreased in size. It is now the Jacksonville Mental Health and Developmental Center.

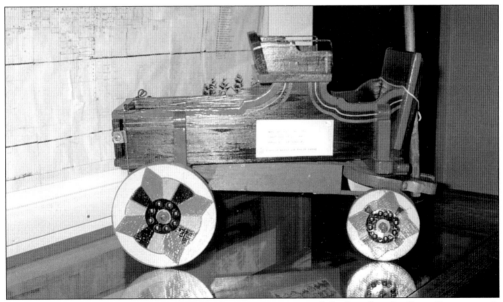

A COLORFUL WAGON, 1931. This colorful toy wagon was made by hand at the State Institution's craft shop for a child named Arnold William Burke Jr. Activities and crafts were readily available and encouraged at the hospital. This wagon is on display at the Heritage Cultural Center on the second floor of the School for the Deaf.

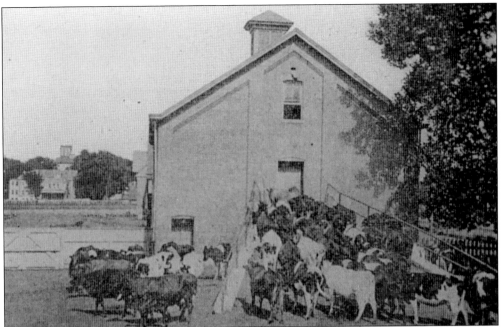

THE MILKING BARN ON THE GROUNDS OF THE STATE HOSPITAL. Prior to 1960, the State Institution provided for between 2,000 and 3,000 patients. The patients contributed to the running of the institution in many ways, from gardening to milking cows. After 1960, many people were released to go back into society, and the Mental Health and Developmental Center now houses approximately 350 people.

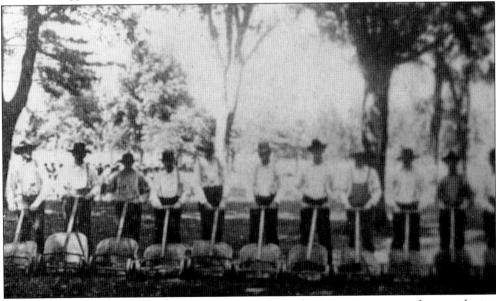

LAWN MOWING AT THE STATE INSTITUTION. Hospital patients participated in gardening activities in many ways. They grew beautiful roses that lined the entire fence along Morton Avenue and around the sides of the immense grounds. Here, the mowing crew sets off around the huge grounds. Patients volunteered and were chosen for different jobs on the grounds, according to their abilities.

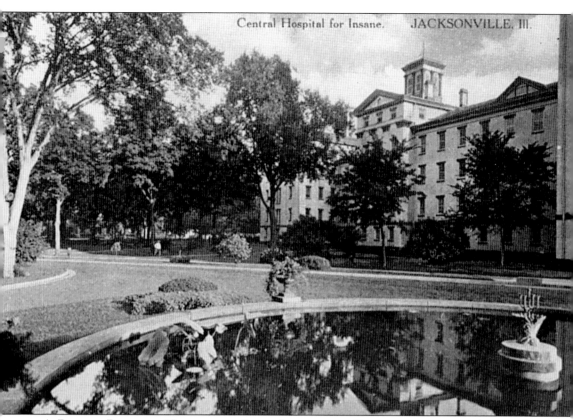

Central Hospital for Insane. JACKSONVILLE, Ill.

A PICTURE POSTCARD VIEW OF THE STATE INSTITUTION. Every attempt was made to make life pleasant at the State Institution (now the Mental Health and Developmental Center) for the thousands of patients being served. Activities, arts, crafts, chores, and entertainment were offered. For years, the hospital met the needs of many people with mental illness. Different approaches to caring for the handicapped have brought changes to individuals and institutions, and the institutions in Jacksonville have changed to keep abreast of the latest developments in the care for people with varied needs.

Four

THE PORTUGUESE TRADITION

In November of 1999, the Portuguese community celebrated the 150th anniversary of its arrival in Jacksonville. Their tradition began on the island of Madeira, traveled with them to Trinidad, to New York City, and finally, in 1849, to Illinois.

While Jacksonville was still a new community, struggling to meet its daily needs, far away on almost the other side of the world, events were set in motion that would bring complete strangers together in a situation that benefited them both. Circumstances forced a Presbyterian missionary and his wife to set up their mission field right where they were, in Catholic Portugal, instead of in China where they had intended. Things went well for a while, and many were converted to Protestantism. When persecution started and arrest threatened, they chose to flee to Trinidad.

The American Protestant Society of New York heard of their plight and sought to help. A wonderful arrangement was made with the American Hemp Company of Island Grove, Illinois, which promised immediate employment, good wages, and 10 acres of land to every family who came. This was an offer that seemed, and was, too good to be true. The hemp company folded, but not before some Portuguese were on their way. The solution was for the Presbyterian churches, in both Springfield and Jacksonville, to find housing and jobs for these newcomers. They arrived, found mostly success, and built several of their own Presbyterian churches in Jacksonville and Springfield.

The Portuguese traditions continue in the community and at the Northminster Presbyterian Church.

Two Portuguese Children. The 150th anniversary of the Portuguese coming to Jacksonville was celebrated in November of 1999. Pictured here are two beautiful Portuguese children. Because they arrived in a few large groups, 250 or so at a time, their immigration story is unusual. But in many ways, their story is similar to other groups who came to the United States, and Jacksonville in particular, seeking a better life and bringing their own traditions with them. Even the early settlers from New England were immigrants, in a way, although they spoke a common language. When groups of German and Irish immigrants arrived, they faced the same challenges of housing and employment as everyone else on the prairies. However, they also had the added challenge of learning a new language to compound their adjustment. Blacks arrived with the challenge of beginning new lives after slavery. And so, as we especially remember the challenges and contributions of the Portuguese story, remember also the other immigrants who came seeking a good life, which includes every one of us.

JOSEPH DE GOVEIA, BUILDER AND CITY ALDERMAN. Pictured here in his office is Joseph De Goveia, a building contractor and city alderman. He built many businesses and several large homes, including 1605 Mound Avenue and 1249 West State Street. With the popularity of cigar manufacturing in Jacksonville (13 factories, hand producing 200,000 cigars a week), some Portuguese found employment in cigar factories. Others farmed, worked in Capps Mills, and worked on the railroad. In 1889, Joaquin Vasconcellos was employed as chief of police.

DE SILVA'S RESTAURANT. Charles De Silva's restaurant was a favorite eatery on State Street. In 1917, a lunch of wieners and kraut cost 10¢. Fried chicken dinner, with all the trimmings, cost 50¢. De Silva's Chili, and Chili Mac, were available in grocery stores. Mr. De Silva is seen sitting at the counter in this photograph. He retired in 1949.

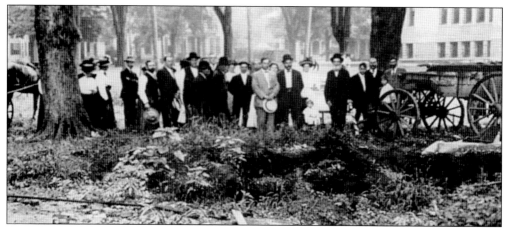

GROUNDBREAKING AT NORTHMINSTER, 1909. Two hundred eighty Portuguese arrived in Jacksonville in November 1849, and they quickly began to organize their own church. In 1850, the First Portuguese Presbyterian Church was organized, and by 1853, they had constructed a building at the corner of Jordan and Kosciusko. Dr. Robert Kalley himself, the original missionary, immigrated to Jacksonville, and upon his arrival, Second Portuguese Presbyterian Church was founded. Central Portuguese was founded next, but the community was realizing that they could not support three churches, so they united in 1900 and constructed a new church, Northminster Presbyterian. Pictured here is the groundbreaking for the new church.

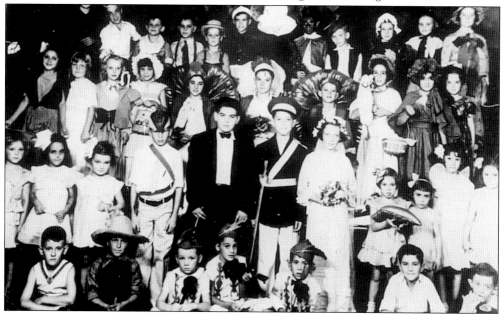

CHILDREN'S PAGEANT AT NORTHMINSTER PRESBYTERIAN CHURCH. In this photograph, many children of the Portuguese congregation are posing in costume for a pageant at the Northminster Church. The year is about 1935, and some of the children are identified: Front row, at the far right is Jack Dawson. Row two: ?, Ethel Colleen Allen, Barbara Bieber, ?, George Robert Coraor, Charles Aguar, Jacqueline Wyant, ?, Mary Delores Vieira, ?, ?. Row three: Ardeen DeFrates, ?, ?, Doris Marie Souza, Mari Margaret Pires, ?, ?, Helen Louise Vieira, Donne Lou Day, and Joyce Souza. Fourth row: the only one identified is William DeFrates, fourth from left.

Five

RELIGIOUS TRADITIONS

Coming way out west to the wild prairie state meant leaving families, friends, and an old life behind. But settlers did not leave behind their conviction that God was going with them to lead and direct them to a better life. The religions which they brought with them were as diverse as the settlers themselves. The Baptist and Methodist traditions tended to come with the southerners, and the Presbyterian, Congregational, and Episcopal traditions tended to come with the northerners. These earliest traditions soon made room for Lutheran and Catholic traditions.

The Methodists began "classes" in 1822, as Peter Cartwright and others rode the circuit in Illinois. The honor of being the first church in the area usually goes to the Diamond Grove Baptist Church in 1823. The Presbyterians organized in 1827, the Christian Church began in 1831, the first Episcopal church in the state organized as Trinity in 1832, the Congregationalists began in 1833, the Ebenezer Methodist Church and school began in 1835, and the Mt. Emory Baptist Church was established in 1837.

Different styles of worshiping appealed to different folks, with each group comforted in unique ways. Though the citizens may have differed on Sundays, they agreed on weekdays to work together for the common goal of bettering the Jacksonville community.

And strong religious traditions continue today.

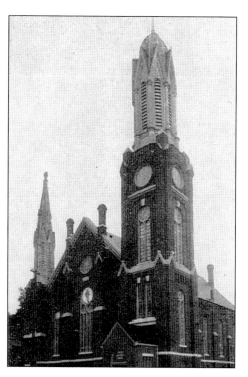

CENTENARY UNITED METHODIST CHURCH, DEDICATED 1866. A Methodist class was organized in 1822 by Peter Cartwright, a circuit-riding preacher, in the cabin of John Jordan. Peter Cartwright actually lived in Pleasant Plains, but his circuit included Jacksonville, and he was an important figure here. The beginnings of Centenary, Grace, and Brooklyn Methodist churches date their founding to this time. Centenary Church has close ties with MacMurray College, located in close proximity.

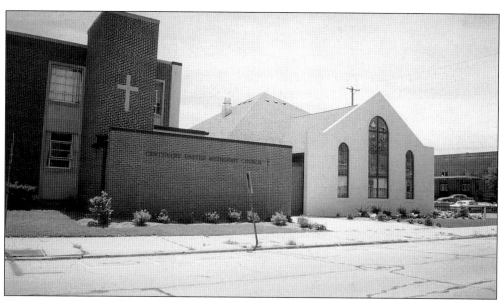

CENTENARY UNITED METHODIST CHURCH, DEDICATED 1998. With the passage of time, the old church was deemed no longer safe, and the congregation bravely said goodbye to the old structure and welcomed a new one in its place. The old church had held not only church services, but also chapel services, classes, concerts, and commencements for MacMurray College.

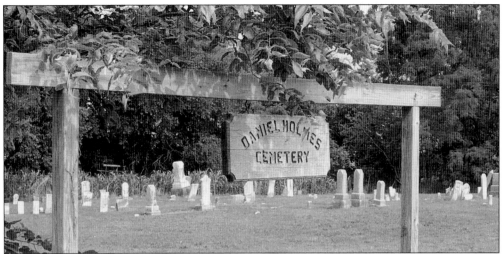

THE DIAMOND GROVE BAPTIST CHURCH CEMETERY. The Diamond Grove Baptist Church was organized April 26, 1823, by a New Yorker named Jonathan Sweet. One of the sons of the church, Daniel D. Holmes, became the pastor in 1865, and the church's adjoining cemetery was named in his memory. It is located on the far southeastern edge of Jacksonville. Of course, the church is long gone, but the cemetery remains far out on east Vandalia and the Holmes family still resides in the neighborhood.

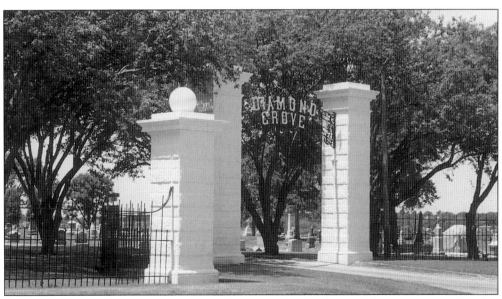

DIAMOND GROVE CEMETERY, ON SOUTH LINCOLN. By thinking of the two cemeteries that share the name Diamond Grove, we can easily imagine the extent of the famous Diamond Grove referred to by early settlers. Coming across the wide prairies in assorted wagons, the flat landscape of fertile fields was broken by a grove of trees 4 to 6 miles long. To them, in the light of a cold, frosty morning, it seemed to sparkle like diamonds, hence the name Diamond Grove. Think of the two cemeteries as bookends for the grove and it gives an idea of its rather enormous extent.

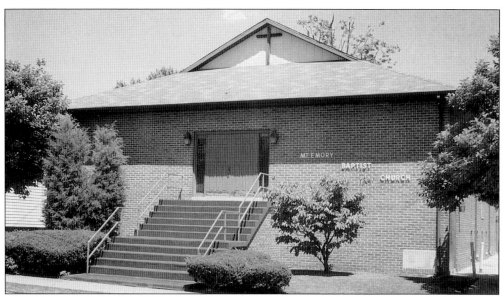

MOUNT EMORY BAPTIST CHURCH, FOUNDED BY REVEREND A.W. JACKSON. In 1837, the Mount Emory Baptist Church was founded with the Reverend A.W. Jackson as the minister. He had been a barber in Jacksonville, but responded to the church's call for to preach, and he prepared himself by his own study. He helped strengthen other African-American Baptist Churches in Illinois. He also served as a city alderman in Jacksonville.

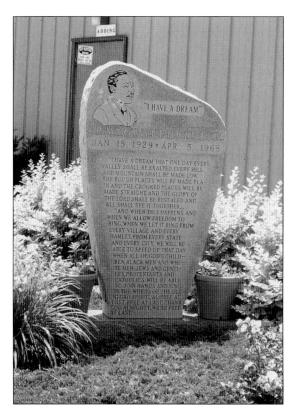

SPIRIT OF FAITH, FAITH CENTER. The memorial to Dr. Martin Luther King Jr. stands outside the Spirit of Faith, Faith Center in recognition of the work Dr. King did to secure equal rights for people of color in the United States. Inside this church, the work continues in the hands and hearts of the dedicated church members led by the Caldwell family. Pastor JoeAnna Caldwell guides and leads the congregation, as her husband, Paul, did before her. The soup kitchen should be recognized as an impressive ministry to the neighborhood surrounding the church.

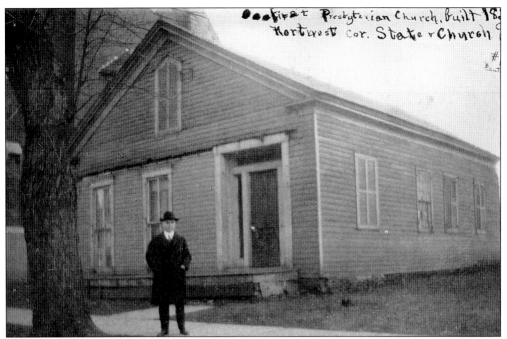

The handwritten note on the photo reads: "First Presbyterian Church, built 18... Northwest cor. State & Church"

THE FIRST PRESBYTERIAN CHURCH OF JACKSONVILLE, DEDICATED JUNE 19, 1831. This unassuming frame structure housed the Presbyterian Church from 1831 to 1847, at the northwest corner of State and Church Streets. By 1874, the Second Presbyterian Church returned to this site and built a new Romanesque red brick building. This was later sold to the First Baptist Church, when the First and Second Presbyterian congregations reunited as the State Street Presbyterian Church on the northeast corner.

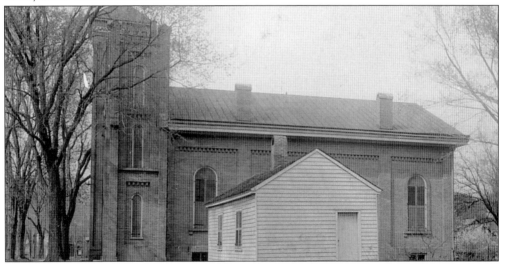

WESTMINSTER CHURCH AND LITTLE WHITE SCHOOL, 1867. This congregation was organized May 13, 1860. Their first building faced Westminster Street just north of the little white school on College Avenue. The red brick structure was torn down in 1900 upon completion of the present stone edifice. It is interesting that the Presbyterian congregations of Jacksonville have grown, changed, split, and reunited several times over the years. Presently, there are two Presbyterian churches, First and Northminster.

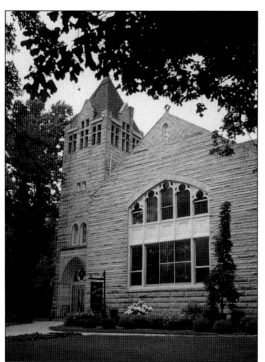

WESTMINSTER PRESBYTERIAN CHURCH, 1900. In 1900, the Westminster Presbyterian Congregation erected a stone church at the corner of College and Westminster. It was described as " the most elegant and imposing church edifice in Jacksonville." They predicted that the church was arranged so well that a thousand people would not crowd it. This at a time when the membership was about 250. The building is now the home of the First Presbyterian Church.

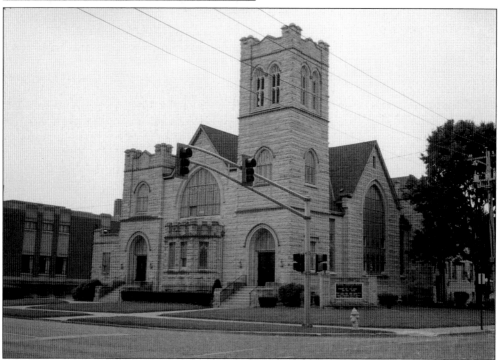

CENTRAL CHRISTIAN CHURCH, 1906. Not to be outdone by the Presbyterians, Central Christian Church erected its new stone facility in 1906, describing it as "probably the finest church building in Jacksonville." The church featured 20 rooms for use by the Sunday School, since the Sunday School movement was gaining momentum at this time.

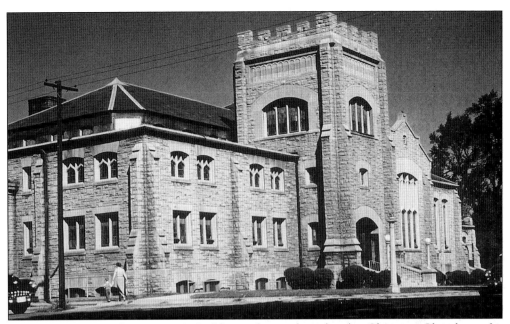

GRACE METHODIST CHURCH, 1910. Not to be outdone by the Christian Church or the Presbyterian Church, and in the spirit of the Sunday School movement, Grace Methodist built a third stone structure in the city, rejoicing that they could seat 1,500 or more. Their membership in 1910 was 685 people! The education portion of the church had 47 rooms to be used as offices and education areas.

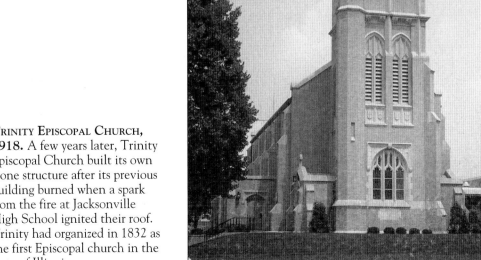

TRINITY EPISCOPAL CHURCH, 1918. A few years later, Trinity Episcopal Church built its own stone structure after its previous building burned when a spark from the fire at Jacksonville High School ignited their roof. Trinity had organized in 1832 as the first Episcopal church in the state of Illinois.

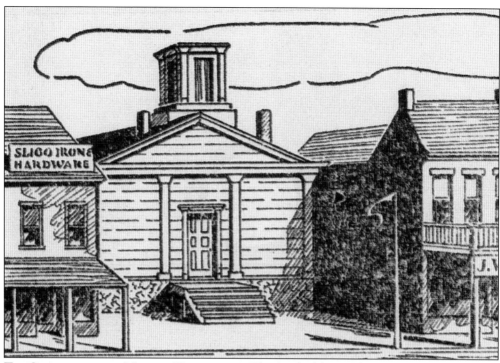

THE CONGREGATIONAL MEETING HOUSE, 1833. The first building of the Congregational Church was constructed on the east side of the Square in 1833. It provided the largest auditorium in town at the time. The bell was removed from the belfry, and tradition has it that it cracked when it was rung enthusiastically during the town's celebration of the Union victory at Richmond, Virginia.

THE CONGREGATIONAL CHURCH, 1859. In 1859, the present Congregational Church was erected on West College. The church was illuminated by gas lamps, the very most modern kind of lighting, and the congregation illuminated the town of Jacksonville with their leadership in the cause of abolition of slavery.

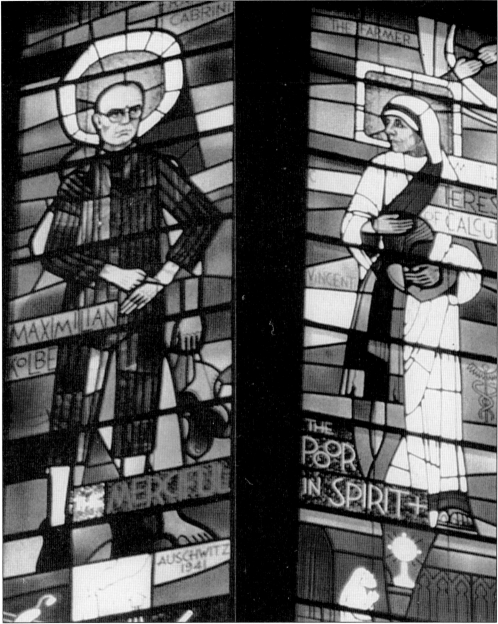

THE CHURCH OF OUR SAVIOUR. The Church of Our Saviour celebrated its first mass in 1851 with a few families led by Father Gifford from Springfield. Their traditions grew and continue today in the church built in 1977. Those fortunate enough to see these stained-glass windows first hand know the impact they have on the viewer. Two windows are pictured here. On the left is Maximillian Kolbe, a Polish Franciscan priest who gave his life in a concentration camp to save a man with a family. Inserts on this window include an electric fence, crematory, swastika, and the inscription, Auschwitz, 1941. Behind him is the condemned man holding his boots, a sign that he was picked to die. On the right is Mother Teresa of Calcutta, India, with her arm around a poor little girl. The caduceus in the insert indicates her medical work.

BILLY SUNDAY, REVIVALIST. Billy Sunday was born in Ames, Iowa, 1862, and spent his early years in orphanages and with grandparents. He played major league baseball for Chicago, Pittsburgh, and Philadelphia. Billy was converted and began working for the YMCA. He was a Presbyterian minister noted for slangy language and highly developed promotional methods. He believed he spoke to over 100 million persons and converted over a million. In rousing sermons, he denounced "evolution, card players, dance devotees and theatre gadders." A Billy Sunday All Star Team was featured and there were many musical highlights during the revival. Billy Sunday stayed in Jacksonville for six weeks and spoke in front of 249,459 people. There were 3,002 converts. He was paid $8,000 for his work.

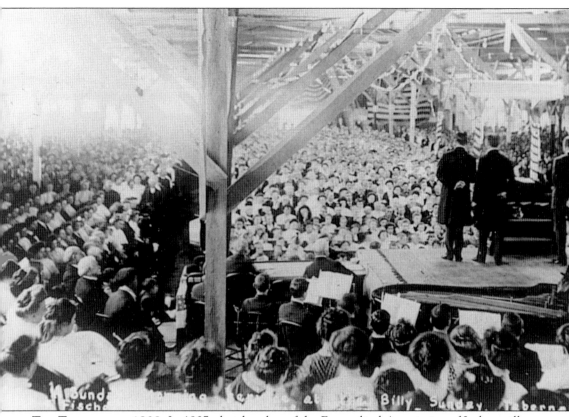

THE TABERNACLE, 1908. In 1907, the churches of the Evangelical Association of Jacksonville believed that drunkenness, gambling, and immorality could be curbed if the saloons were shut down. They worked together to build support for a "dry" law to be passed. It did, and the Association next turned to a camp meeting as a way of saving sinners. They built the Tabernacle in 1908, and invited the famous Billy Sunday to come for a series of revival meetings. Billy was described by the Reverend Joseph C. Nate of Grace Methodist Church as a "moral cyclone, a prophet sent from God . . . for the salvation of Jacksonville." The Tabernacle featured 400 lights, 2 telephones, and bunting and streamers. The crowds were so great that some wished they had built a larger Tabernacle. The overflow spilled into Centenary Methodist Church. Soon after the revival, the Tabernacle was torn down.

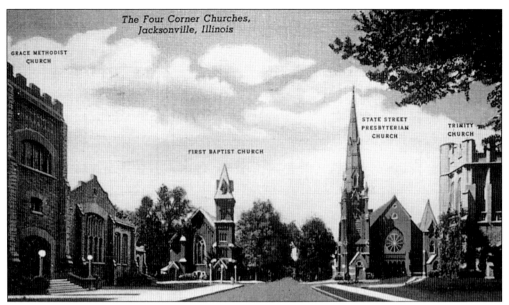

THE FOUR CORNERS CHURCHES, AT STATE AND CHURCH STREET. At one point in time, four different denominations had churches on the same corner in Jacksonville. Since one street was actually called Church Street, this was quite a famous corner in its time. The church on the Northwest corner was the First Baptist Church. It was used from 1897 to 1966 when it burned. The Grace Methodist Church on the Southwest corner is still standing and gracing the corner with its presence. The church on the Northeast corner was the State Street Presbyterian Church. Trinity Episcopal Church is the oldest Episcopal congregation in the state of Illinois. It still stands on the southeast corner of State and Church.

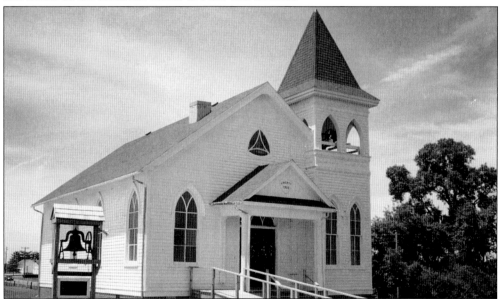

LIBERTY CHURCH. This renovated church is now located on the grounds of the Prairieland Heritage Museum Institute. It was brought here from the Markham area of Morgan County to serve as a reminder of our small church heritage. The church is still used for services on some Sunday evenings, and is available for small weddings. The tin ceiling is painted white.

Six

THE HISTORIC SOCIETIES

The strong tradition of continuing education took root in Jacksonville in the form of societies. Pioneer women as well as pioneer men were concerned with being as educated as possible even out on the prairie. At a time when women were discouraged from getting an education in many parts of the country, the women in Jacksonville were determined not to be left behind the college-bound men in their families. Oh, sure, some were ridiculed, and stories are told of women who took shortcuts and back ways to get to their society meetings so as not to be seen by less interested neighbors.

In fact, the first society in town was formed by women who named it the Ladies' Education Society (1833). This is now the oldest independent woman's society in America. It provided grants to "encourage and assist young ladies to qualify themselves for teaching."

Men founded the first two literary societies, The Club in 1861, and the Literary Union in 1864. Women founded their own literary societies beginning with Sorosis in 1868, believing that they "should be equipped by study and education to share with man both the responsibilities and the problems of everyday life." This was followed by the Household Science Club (1885), Wednesday Class (1887), Monday Conversation Club (1888), College Hill (1888), and the History Class (1896).

Some societies like the Plato Club and the Microscopical Club are no longer active. But the tradition of bettering oneself through continued education continues.

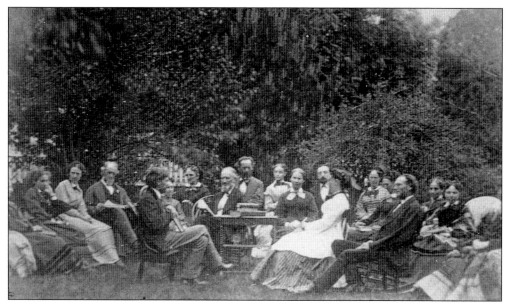

THE PLATO CLUB 1860. The only requirement for membership in The Plato Club, was an honest desire to "know oneself." The club met in the morning when the mind was freshest, and read and re-read the works of Plato. Their discussions would "elevate them for a time, at least, into some restful and purer realm." Pictured here are Mrs. Ellen Ramsey, Miss Edith Wolcott, Miss Louisa Fuller, Elizur Wolcott, D.H. Harris, Miss Mary King, Mrs. M.J. Kellogg, Dr. Hiram K. Jones, Charles Drury, Miss Lizzie Wright, Mrs. Martha Wolcott, Miss Mary Selby, Louis J. Block, Mrs. Clayton, Mrs. Hiram K. Jones, Mr. Clayton, Mrs. J.O. King, Mrs. Charles Drury, and Mrs. D.H. Harris.

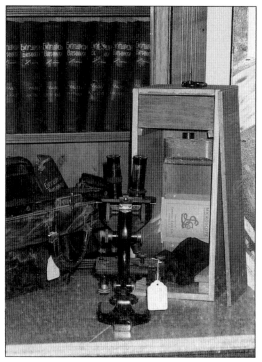

THE MICROSCOPICAL CLUB, 1876. With the invention of the microscope came an interest in a club to study the "infinitely little." Microscopes cost at that time between $100 and $800. Membership included those who wished to be on the cutting edge of new technology, which meant, in this progressive community, that women were allowed. Drs. Black, D. Prince, A.E. Prince, H.K. Jones, C.G. Jones, Frost, Freeman, and Pitner were members, as were Miss Alice Rhoads, Miss Fuller, and Mrs. H.W. Milligan. At each meeting, a subject was announced for study, and at the next meeting, slides of specimen were shown which members had prepared.

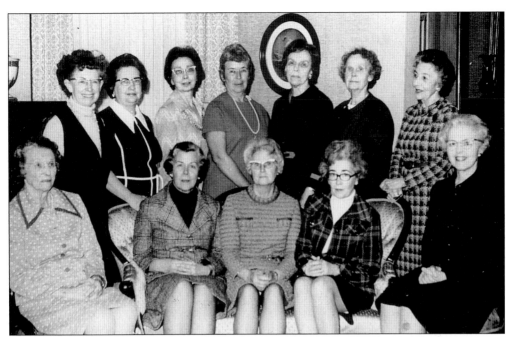

THE LADIES' EDUCATION SOCIETY OF JACKSONVILLE, ILLINOIS. On October 3, 1833, "The Ladies' Association for Educating Females" met to organize monetary assistance for females wishing to advance their education. This is the oldest independent woman's association in the United States. This organization continues offering grants today. Pictured here in 1975 are (front row) Miss Anne Bellatti, Mrs. J.B. Wright, Mrs. Lawrence Crawford, Mrs. Robert E. Spink, and Mrs. Walter Bellatti; (back row) Mrs. Friedrich Engelbach, Mrs. Robert F. Siebert, Mrs. John Hinde, Mrs. James Coultas, Mrs. John T. Hackett, Mrs. Joe Patterson Smith, and Mrs. S.N. Osborne.

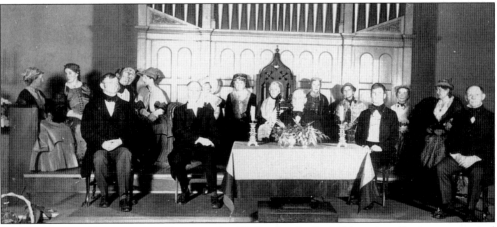

CELEBRATING 100 YEARS OF SERVICE. In 1933, the Ladies' Education Society reenacted a meeting of the society in the Congregational Church. In the old days, women were not "allowed" to speak in public, so men read their reports for them. In this costumed reenactment, modern men dutifully played their part and read the reports. Pictured here are (front row) Walter Bellatti Sr., Dr. F.B. Oxtoby, Hoyt C. Franchere, Dr. R.O. Stoops, and Dr. R.H. Lacey; (back row) Margaret Moore, J.C. Rammelkamp, Maria Fairbanks, Ruth Bailey, and Phoebe Bassett.

THE CLUB, FOUNDED IN 1861. "Tuesday evening, September 17, 1861, a number of gentlemen met at the residence of Professor Sanders for the purpose of forming a club." The names sound like a roll call of early Jacksonville, including, J.M. Sturtevant, Samuel Adams, R.C. Crampton, William G. Gallaher, D.H. Hamilton, E. Wolcott, C.H. Marshall, Henry Jones, David Smith, Andrew McFarland, M.P. Ayers, Rufus Nutting, E.P. Kirby, J.B. Russell and W.D. Sanders. Their first topic of conversation was, "What should be the immediate policy of the government in respect to the slave proposition?" The fourth meeting of The Club was held in President Sturtevant's home at 252 S. Park (above). The Sturtevant family lived in this home for more than three decades. President and Mrs. C.H. Rammelkamp lived in the home from 1907 to 1910. In 1933 it was made a women's dormitory and named "Fayerweather House" in honor of Mr. Sturtevant's two wives, Elizabeth and Hannah Fayerweather.

THE LITERARY UNION, FOUNDED IN 1864. On the evening of April 14, 1864, a company of men assembled at the home of William Brown, 857 West State Street, and organized the Literary Union "to promote useful knowledge and correct taste among its members, and to devise plans for the good of society." The original group included Livingston Glover, William Brown, Robert W. Allen, Elisha W. Brown, William Brown Jr., William Dod, Clinton Fisher, Phillip G. Gillett, Hiram K. Jones, John Loomis, B.F. Mitchell, Theodore N. Morrison, John H. Wood, and John H. Woods. Many remember the tradition of serving hot chocolate with whipped cream at their meetings. The George M. Chambers House at 829 West State Street (above) is one of Jacksonville's oldest homes, the back portion dating to 1841. This home is known to have been the scene of simultaneous meetings of Sorosis and Wednesday Class when Nancy Chambers Moore lived in the home. After meeting separately in the two parlors, tea was served together. Today, it is a home for Literary Union meetings as a current member resides there.

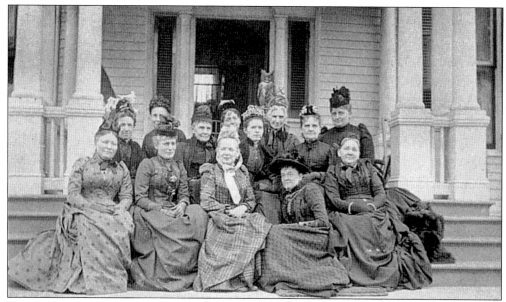

Tenth Anniversary of Sorosis, 1878. On November 30, 1868, five Jacksonville women met in the home of Mrs. Josephine Milligan for the purpose of forming a society to study "literary and scientific subjects and the discussion of current events." The women of Sorosis posed for this tenth anniversary picture on the steps of the Governor Duncan Home. The event was hosted by Julia Duncan Kirby. Pictured are (front row) Mrs. Paterson, Mrs. King, Mrs. Kirby, Mrs. Dummer, and Mrs. Barclay; (second row) Mrs. Fuller, Mrs. Wolcott, Mrs. Prince, Mrs. Milligan, Mrs. Lambert, Mrs. Jones, Mrs. Hall, and Mrs. Myers.

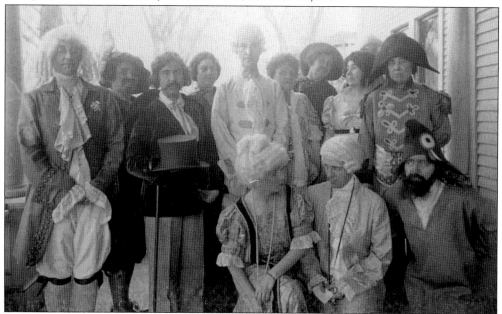

Sorosis, in the 1920s. When Mrs. Josephine Milligan organized Sorosis in 1868, she modeled the organization after a successful venture in New York, making it the second organization of Sorosis in the United States. France was the theme of the year of this photo, culminating in this costumed gathering on a large porch.

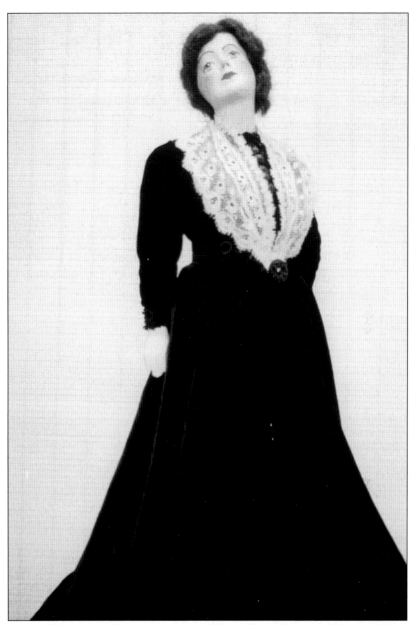

MRS. JOSEPHINE MILLIGAN, FOUNDER OF THE HOUSEHOLD SCIENCE CLUB, 1885. Josephine Milligan, 1835–1911, was the organizer of both the Sorosis Club in 1868 and The Household Science Club in 1885, whose members included herself, Mrs. Joseph Bancroft, Mrs. Fitzsimmons, Mrs. Lizzie Jones, Mrs. Martha Orr Kellogg, and Mrs. A.C. Wadsworth. For more than a century, the members have held firmly in their belief that household science is infinite in pleasure, in resources, and in opportunity for service to others. Their program for the year 1999–2000 is "A Celebration of Women," including Georgia O'Keefe and Mary Engelbreit. Josephine Milligan was interested in everything, and her collection of dried wild flowers of Central Illinois was so valuable that it was placed in The Smithsonian Institute in Washington, D.C. She also wrote articles for the *New York Times* and was an early member of the Ladies' Education Society. (Courtesy of the DAR.)

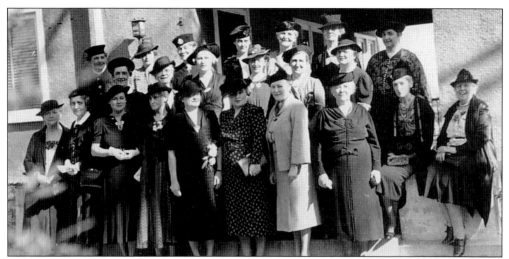

WEDNESDAY CLASS CELEBRATES THEIR 50TH ANNIVERSARY, 1937. Wednesday Class began gathering in 1887 "for mutual study and improvement." In 1892, they began having one meeting a month devoted to current topics. Women's right to vote was often discussed, and, in 1924, Wednesday Class omitted one meeting so all members could attend the School of Citizenship. Shown here on their 50th anniversary are the following: (front row) Bessie Black, Clara Nelms, Irma VanMeter, Fannie Weir, Mabel Waddell, Marian Bellatti, Temple Irwin Grout, Isabel Woodman, and seated are Madge Barnes and Emily Bancroft; (middle row) Irene Brouse, Sarah Maria Fairbank, Charlotte Ryan, Alice Engelbach, Katherine Milligan, Ruth Moriarty, and Rose Rainey Lacey; (back row) Courtney Crouch Wright, Carolyn Crawford, Clara Williams, Gertrude Ayers, Minna Adams, and Caroline Johnson.

WEDNESDAY CLASS CELEBRATES THEIR 90TH ANNIVERSARY, 1977. Anniversaries of Wednesday Class were frequently celebrated with progressive luncheons. In 1977, Mrs. Alice Appleby and Wednesday Class celebrated their 90th birthdays together. Pictured here are (first row) Alice Applebee, Alice Engelbach, and Vicky Dollear; (second row) Jessica Sibert, Charlotte Cleeland, Rhoda Clark, Marta Hartley, and Judy Zink; (third row) Betty Fay, Carolyn Crawford, Helen Dial, Cathy Green, and Joy Becker; (fourth row) Lynn Williams, Becky Matthew, Pat Schildman, Adeline Brown, and Joyce Bills.

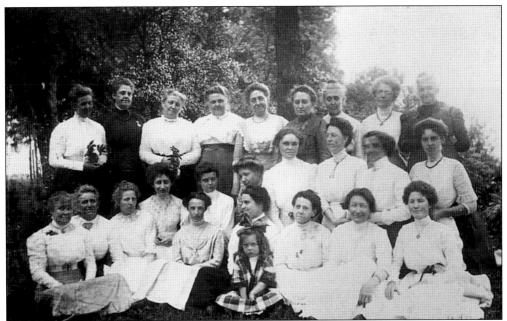

MONDAY CONVERSAZIONE CLUB, 1918. In 1887, the founders of Monday Club met to plan a society that differed from existing societies in one particular way; the papers to be presented must be thoroughly researched and yet presented without the aid of written notes! Early topics included *Emerson, Historic Alaska,* and *Russian Literature*—without notes! Rules have relaxed a little since then. This photo in 1918 is at the home of Mrs. Hinrichson.

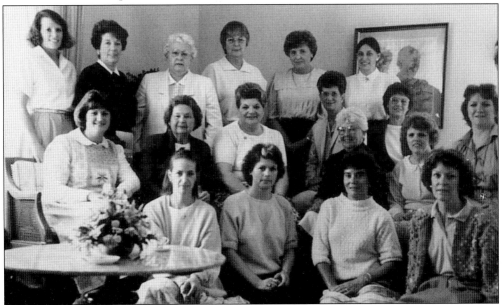

MONDAY CONVERSATION CLUB. At the 100th Anniversary celebration of Monday Conversation Club were the following: (front row) Lynn Scott, Chris Spink, Addie Coultas, and Vicki Brooks; (middle row) Leslie Ware, Marjorie Kanatzer, Caroline Gross, Bobbe Lukeman, Gratia Coultas, Marti Gray, Penny Mitchell, and Sally Dahman; (top row) Pat Foss, Donna Cody, Esther Chrisman, Pat Abbott, Shirley Husa, and Barbara Hanson.

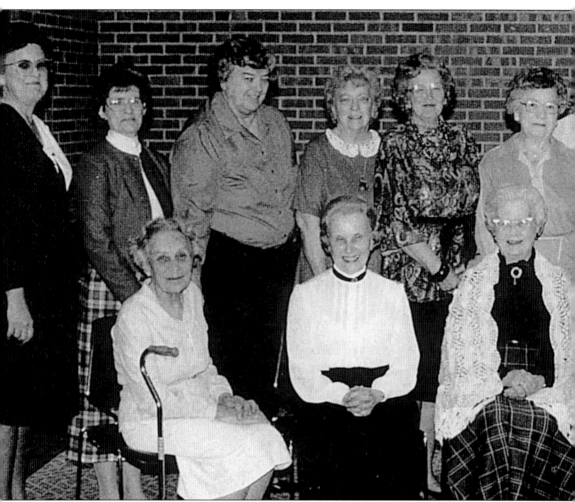

COLLEGE HILL CLUB, 1888. College Hill Club met for the first time in the home of Mrs. E.A. Tanner, whose husband was then president of Illinois College. The six original members were Mrs. Tanner, Mrs. H.C. Hammond, Mrs. S.W. Parr, Mrs. H.W. Johnston, Miss Annie E. Tanner, and Miss Marian B. Tanner. The stated purpose of the club was mutual improvement by the study of the lives and works of famous men and women and important events in history. In the beginning, two and sometimes three papers were presented in the afternoon's program! At their second meeting, on December 31, 1888, the two papers were "English History to the Norman Conquest" and "English History in the 12th Century." Later, one paper per

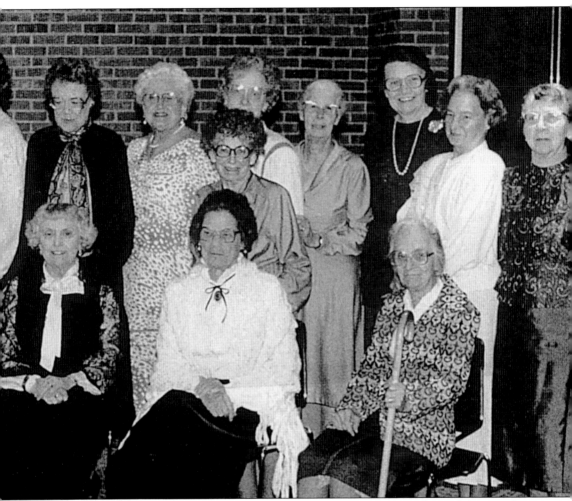

program was deemed sufficient. Shown in the photo are College Hill members celebrating the Centennial Anniversary of the organization in October 1988. Pictured here celebrating their 100th anniversary are the following: (front row) Dr. Suzanne Robbins, Esther Meyer, Elma Dixson, Marjorie Heiss, Kay Pigott, and Dorris Hendrickson; (second row) Charlotte Jackson, Joyce Pratt, June Bradish, Mary Manlove, Mildred Riley, Kathryn Sheppard, Sandra Carpenter, Mickey Smith, Beatrice Hartman, Alice Engelbach, Mary Flo Stewart, Jean Hildner, Marjorie Gustafson, Edith Fernandes, and Dorothea Ryberg.

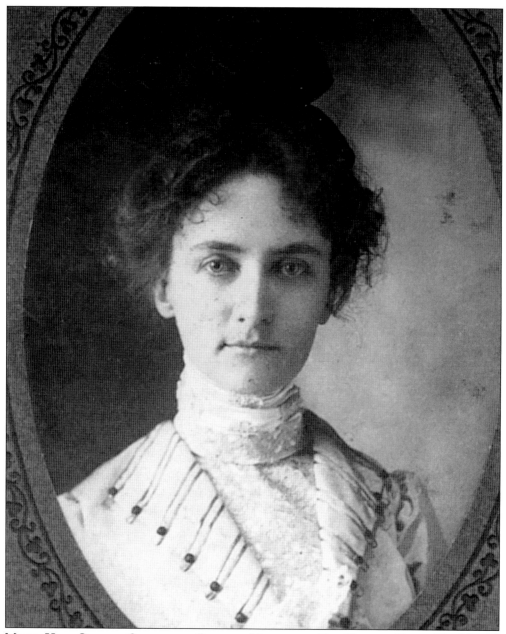

Mabel Hall Goltra, One of the Original Members of The History Class. The History Class organized under the auspices of The University of Chicago on September 7, 1896, and called itself The University Extension Club. For several years, plans of study were sent from Chicago to the class in Jacksonville for a small fee. On several occasions the lessons didn't arrive on time, and in the fall of 1901, the name was changed to The History Class. In 1914, the class voted to donate their annual dues to a milk fund at Dr. Josephine Milligan's "open air" school for children. For the program year 1917–1918, it was decided to give up the scheduled program for the year and respond to the urgent plea of the Red Cross by working for it while the leader for the day read from the History of Illinois, compiled by the Illinois Centennial Association.

Seven

TRANSPORTATION

Jump in your car in the year 2000 and you can be in Springfield in about 30 minutes. In a wagon in 1800, it took all day, from sun up to sun down. Now imagine the trip by train in 1842. It took 2 1/2 hours, unless the train needed fuel or water which required passengers to hike to the nearest river to get buckets of water, or to the nearest grove of trees to get firewood.

Trains were important to Jacksonville's growth. They brought passengers, mail, and supplies for individuals and for stores. They were also inconsistent, difficult to maintain, and they ran right through the center of town! This was thought to be helpful until citizens actually experienced the event with its accompanying noise, delays, smoke, steam, and confused horses. In 1847, the trains were rerouted a bit outside of town to everyone's delight. Of course, as Jacksonville grew, they became less and less "outside" of town.

Horse-drawn trolleys were a common sight around town for many years. They were replaced with electric streetcars, which were a quick, easy, inexpensive way to get around..

Now the trolleys and streetcars are gone, as are the horse and buggies, but in the train whistles today, we hear the echo of early traditions which still continue.

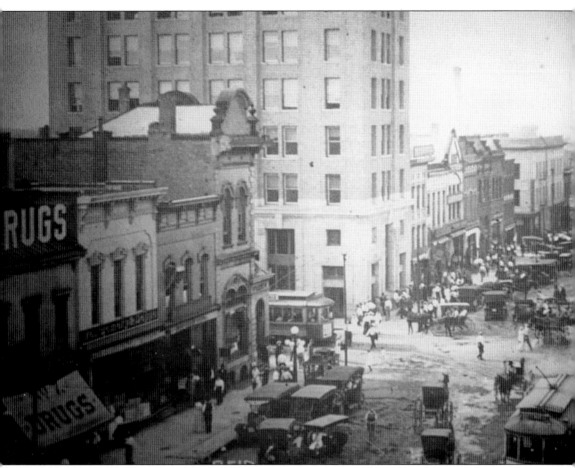

Traffic With No Right of Way. It is fun to imagine the early chaos on the streets of Jacksonville when early cars, horse and buggies, trolleys, and pedestrians all navigated the streets with no stop signs, turn signals, or right-of-way. Somehow, they managed even on rainy, muddy days. The Street Railway Company was incorporated in 1867 by Felix Farrell with the first track laid out on South Main Street. Soon, tracks were laid on East State, West State, and North Main. About 1887, the property was bought by the Hook Company. In 1891, they secured the right to run electric cars.

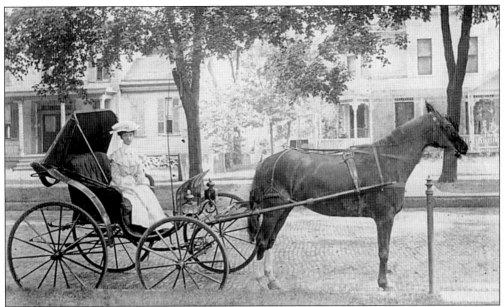

THE GRACIOUS HORSE AND BUGGY DAYS. Life was slower at 616 West College in the days when Mabel Goltra rode through town in her buggy pulled by one horse. The tying post was a common sight in those days, and the ones which remain are a charming reminder of days gone by.

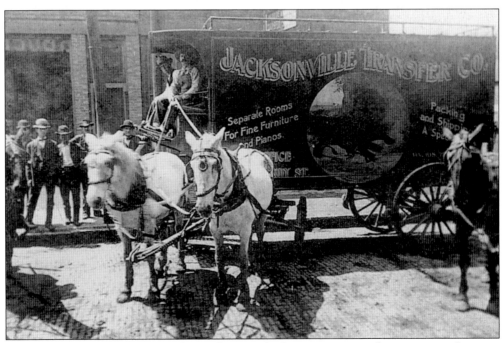

AN EARLY MOVING VAN. The Jacksonville Transfer Company promised to move your furniture carefully, by providing separate rooms for fine furniture and pianos.

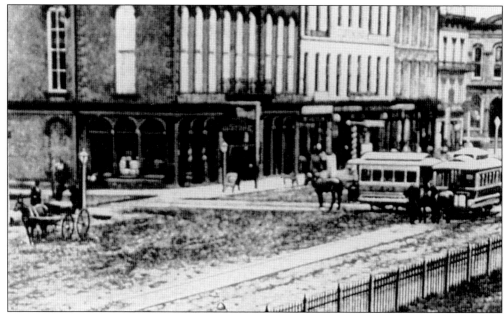

HORSE-DRAWN TROLLEYS. The early trolley lines were laid on dirt streets, which worked better on sunny days than on rainy ones. Perhaps the trolleys are meeting here to transfer passengers from one line to the other. There were lines down North and South Main, and East and West State Street.

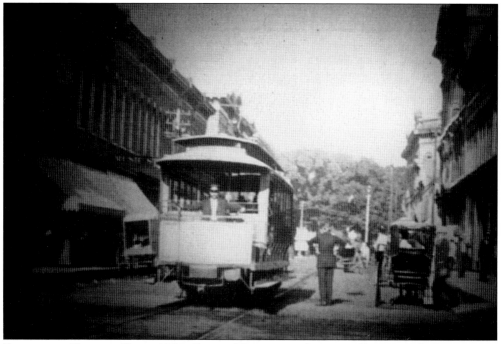

ELECTRIFIED TROLLEY CARS, 1891. Pictured here is an electric trolley car with the engineer seen at the front. Standing next to the trolley is the conductor, announcing or helping passengers. The trolley cars ran until the development of improved automobiles, whose ability to go anywhere without being restricted to tracks foretold the demise of the trolleys.

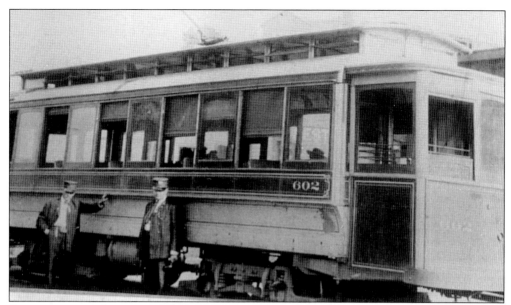

STREETCARS, AN IMPORTANT MEANS OF TRANSPORTATION. Streetcars were a quick and easy form of transportation. In the winter when early automobiles were put up on blocks, folks were thankful for the ride to work, often in the company of friends. Two young girls tell of their solution to beating the summer heat by ordering ice cream from Merrigan's downtown to be put on the trolley and "delivered" to their corner where they eagerly awaited its arrival!

THE WILLIAM S. HOOK HOUSE 1042 WEST STATE STREET. William Spencer played a prominent role in the Jacksonville Street Car industry, and his house was built with adequate windows to view the passing of the streetcars down West State Street. When William died, his sister Fannie lived in the house and continued the tradition of keeping track of the time the streetcars passed the house. Fannie dressed in trousers and smoked a cigar, and "encouraged" on time performance! This Shingle-style house is actually solid brick underneath the weather resistant shingles.

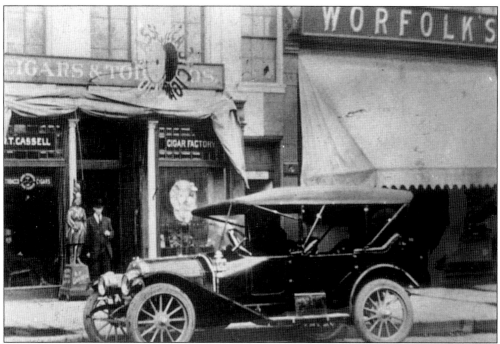

AN EARLY AUTOMOBILE IN FRONT OF CASSELL'S CIGAR STORE. With the popularity of automobiles came the demand for better roads. Dirt roads were the worst during the months of February and March when winter thawed. Roads would be expensive but needed. At a Good Roads meeting in the summer of 1913, a proponent claimed, "Good roads now will increase wealth, health, happiness, education, religion, civilization, and morality."

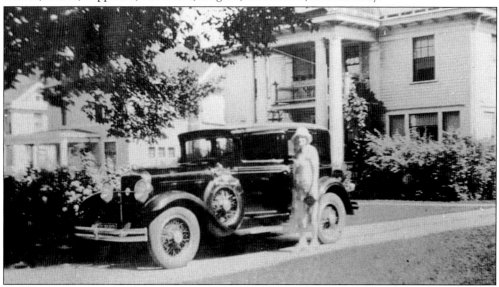

AN EARLY AUTOMOBILE ON MOUND AVENUE. People love to pose with their new cars, and Mrs. Conklin was no different. Here she stands dressed to go somewhere special in front of her home on Mound Avenue. Automobiles were denounced from many pulpits as "a new tool of the devil" because individuals would sometimes take a Sunday joy-ride instead of attending a church service. Mrs. Conklin managed to do both, attend church and joy ride.

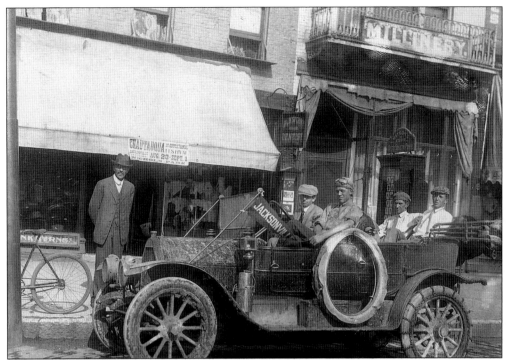

AN EARLY ROADSTER. Pictured here in an early roadster are four young men proudly waving a Jacksonville pennant on their vehicle. They had just returned from a road trip to Chicago. The sign on the awning is advertising *Chautauqua, An Educational Festival, at Nichols Park, August 23 through September 1, 1912*. This roadster is also on the cover of this volume.

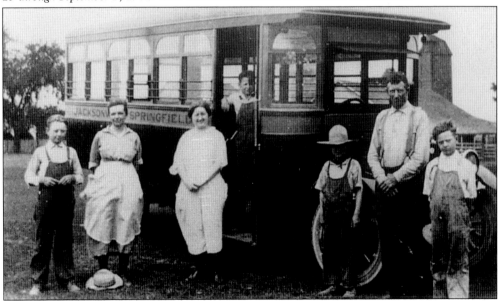

A BUS FROM JACKSONVILLE TO SPRINGFIELD. The bus which ran back and forth from Jacksonville to Springfield was in great demand in the years before "everyone" had a car. The bus line began in 1921 by O.M. Olsen, who had moved to Jacksonville to be near his son at the school for the deaf. He made two trips a day, picking up passengers at hotels and along the way.

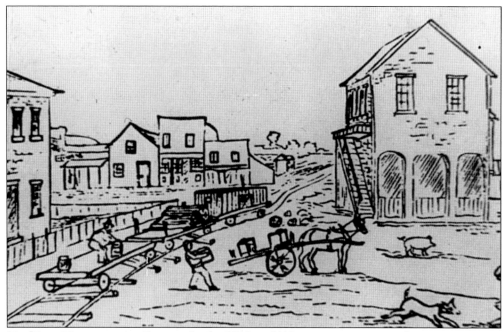

THE FIRST TRAINS ON THE SQUARE. In the 1830s and '40s, trains were seen as the most important factor in the success of our town. They took local goods to market and returned laden with the necessities and luxuries of life. Trains were also noisy and dirty, and they scared the horses as they pulled screeching into town. Tracks were soon moved to farther "outside" of the city. At its peak there were six railroad lines coming in and out of Jacksonville.

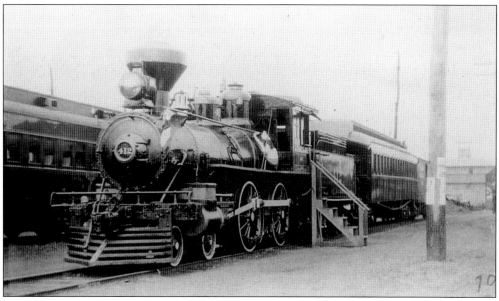

RAILROADS, A LIFELINE IN THEIR DAY. If the pioneer forefathers were to come back to Jacksonville in the year 2000 to celebrate with us the 175th anniversary of the platting of the town, they would be more than a bit surprised at the lack of passenger train service to our community. Passenger trains were the most comfortable, convenient modes of travel for those who could afford a trip.

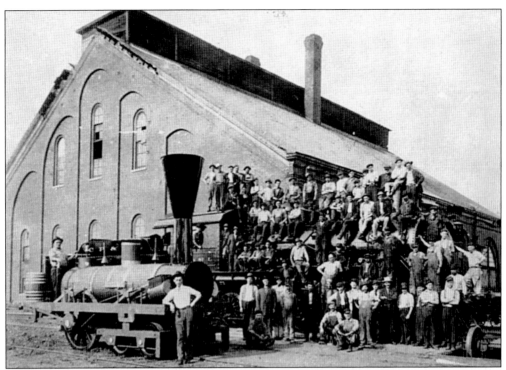

OUTSIDE THE RAILROAD CAR BARNS. Posing with a replica of "The Rogers" is a group of railroad workers sitting atop another engine. "The Rogers" was the first locomotive operated in Illinois. The Northern Cross Railroad ran the Meredosia to Jacksonville route in 1839, and continued on to Springfield in two more years, linking traffic from the Illinois River with landlocked towns like Jacksonville. The Northern Cross evolved into the Wabash Railroad Line.

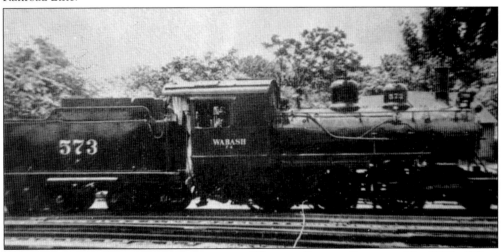

THE LAST STEAM LOCOMOTIVE RUN IN THE WABASH SYSTEM, JANUARY 28, 1955. When times changed and the railroad cars were pulled by stronger diesel engines, the old steam locomotives made their last runs, to the cheers and tears of people who came out to wave one last time. School children were special passengers on those final runs, making a memory to last forever.

SOAP BOX DERBY RACING. The Soap Box Derby usually raced down West College Street, from atop the historical mound down to Prospect Street. Sponsored by Corn Belt Chevrolet, The Exchange Club and the Jacksonville *Journal and Courier*, the races ran almost yearly from 1940 to 1974, with time out for WW II. Girls were finally allowed to race in 1971. Pictured here in 1949 are Billy Slagle of Winchester on the left and Roger Cannell of Jacksonville on the right. The starter is Harold Hills of the Jacksonville Exchange Club.

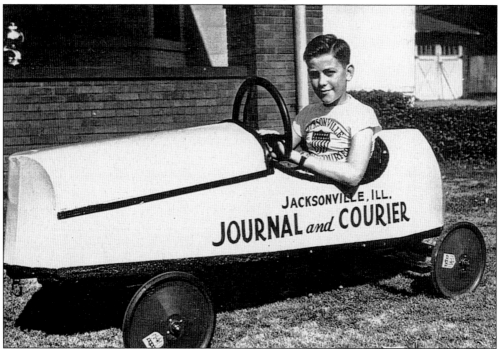

HARLAN WILLIAMSON, WINNER 1940. Harlan Lee Williamson won the first officially sanctioned Soap Box Derby in Jacksonville and advanced to the finals in Akron, Ohio. Trophies were awarded for fastest heat and the best car in such categories as design, construction, brakes, and upholstery.

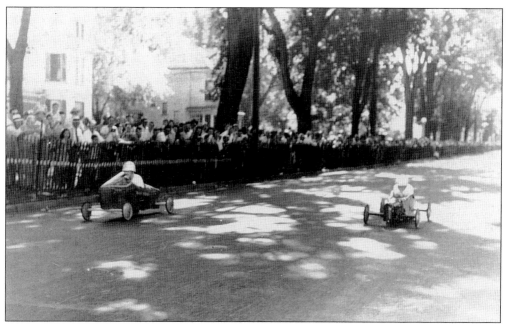

Bruce Samoore, Winner 1946. The Soap Box Derby was not run during WW II, and when it ran again in 1946, an estimated 8,000 people watched as Bruce Samoore won by a nose. "It was really close. I beat him by 8 inches." (Bruce Samoore.)

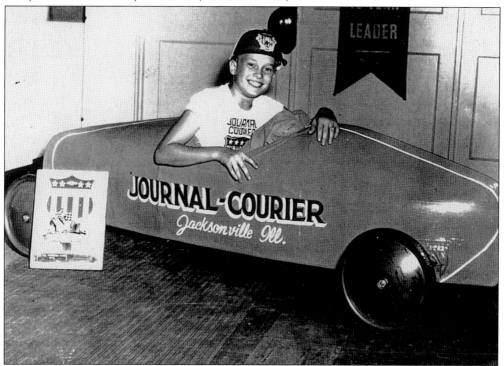

Roger Cannell, Winner 1949. Roger Cannell won the title in 1949 in a car he constructed sponsored by the Jacksonville Appliance Company. At the finals in Akron, Ohio's Derby Downs, his car advertised the Jacksonville *Journal-Courier*.

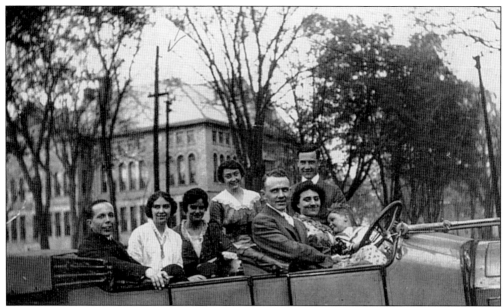

AN EARLY JOY RIDE. Pictured here in an early roadster in front of the high school are (left to right), Warren Case, Alice Wadsworth, Catherine Yates, Mary Wadsworth, A.B. Applebee at the wheel, Elenor Capps, Catherine's intended, and Farrell Crabtree on Elenor's lap.

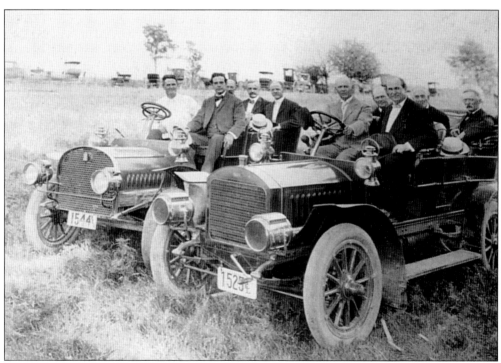

A TEST DRIVE IN DAYS GONE BY. Judging from the row of horse and buggies behind them, these gentlemen are out for a test drive with some lucky owner or salesman. Seated in the front seat of the car bearing the license plate 1523 is William Jennings Bryan. The other distinguished passengers remain anonymous. (Courtesy Heritage Cultural Center.)

Eight

COMMERCE

The fertile land, the booming railroads, and Jacksonville's central location made a successful partnership in the 1850s. Wheat, pork, and a highly profitable cattle trade, led by Jacob Strawn, filled the railcars heading out of town, and the profits they made filled the incoming railcars with the necessities and luxuries of life. Around these agricultural products grew related businesses. A slaughterhouse and a tannery were logical additions to the booming cattle industry. The Capps Woolen Mills made a sensible addition to the sheep industry. Specialty stores began replacing general stores, and cash began to replace bartering and buying on credit.

Water availability was a challenge if the town would attract new industry. A plan in 1868 to develop a waterworks system proved too expensive. Almost 100 years later, in 1955, water was still an issue and an expensive plan to bring water all the way from the Illinois River became a reality. The $2,300,000 project, built with no state or federal funds, guaranteed a water supply and attracted further industry such as A.C. Humko (previously Anderson Clayton).

The old town square remains a shadow of its former self, but nonetheless, it exists. Morton Avenue has replaced it as the shopping strip of choice. Summer days finds the Farmer's Market attracting customers for the freshest produce. Summer evenings finds teenagers circling their cars and trucks around light fixtures in several parking lots on the strip, not so unlike the circling of wagons on the lone prairie as the pioneers gathered for friendship and security as night fell.

And so the traditions change as they continue.

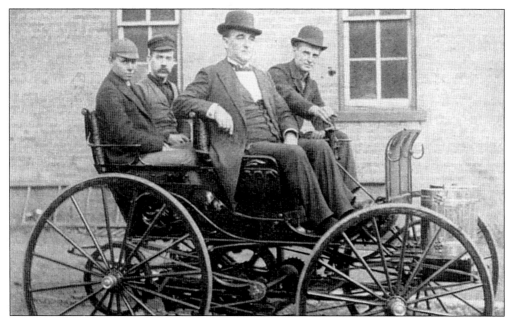

HALL AND SONS BUGGY MAKERS. Having the knack to change with the times and produce what is currently needed is an important business strategy. Mr. Hall is a good example of this. He began as a blacksmith, moved on into buggy making, and ended up with the John Deere dealership. He is seen here driving a car which he built himself.

CIGAR MANUFACTURING. Beginning in the year 1843, cigar making was a big industry in Jacksonville. By 1905, there were 13 cigar factories, employing 130 men and making 200,000 cigars each week. Cigar makers had unionized and were quite prosperous. This cigar factory produced the "El Macco" cigar. At least some of the cigars sold for 5¢.

THE CAPPS MILL, 1839. The production record at Capps Mill shows how a successful business changes over time. The business began as a carding operation, grew into spinning and weaving, began producing finished cloth, began weaving Indian blankets, and began producing men's clothing, including Civil War uniforms, and navy uniforms in WW I.

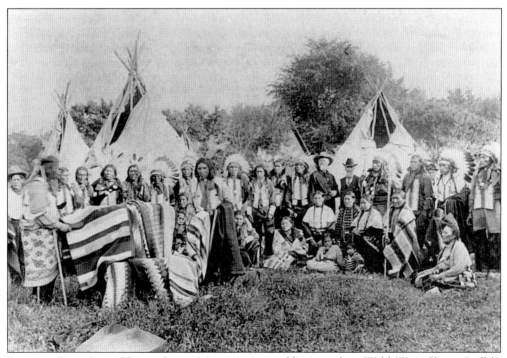

BUFFALO BILL CODY VISITS CAPPS MILL. As part of his traveling Wild West Show, Buffalo Bill Cody came to Jacksonville, and was pleased to find the mill producing excellent Indian blankets. Records show that he purchased several. What he did with them is unknown. In the photo is Buffalo Bill with the members of the show.

THE ELI BRIDGE COMPANY MARKS THE 1,000TH WHEEL SOLD, 1952. Mr. William E. Sullivan went to the Chicago Columbian Exposition in 1893 and saw the huge Ferris wheel running there. He developed the idea for a smaller wheel which would be easier to move from place to place. In May 1900, he operated his first wheel on the town square. He began building more wheels in Roodhouse, but after WW I the operation moved to Jacksonville where a special plant had been built specifically for the purpose of building wheels for fairs and carnivals and amusement parks.

THE BIG ELI (AND OTHERS), 1999. The ability to change has kept many businesses going when others have failed. And so the Eli Bridge Company has begun producing other rides to meet new demands, while continuing to produce the traditional wheels. This is the original Big Eli, standing in front of the Eli Bridge Company.

THE OLDEST LAW FIRM IN MORGAN COUNTY, 1876. John Antonio Bellatti began practicing law in 1876 with Henry Stryker. He was later joined by his son, Walter Bellatti Sr. Later, Walter's sons Walter R. and John E. Bellatti became members of the firm. And the tradition continues in the family today.

AN OVERSEWING MACHINE. This oversewing machine is on display in the Heritage Cultural Museum. It reminds us of the strong tradition in Jacksonville of being the home of book binderies, such as Bound to Stay Bound and Hertzberger New Method. Bound to Stay Bound replaces publishers' bindings with longer-lasting covers. Hertzberger now does Perma binding and rebinding.

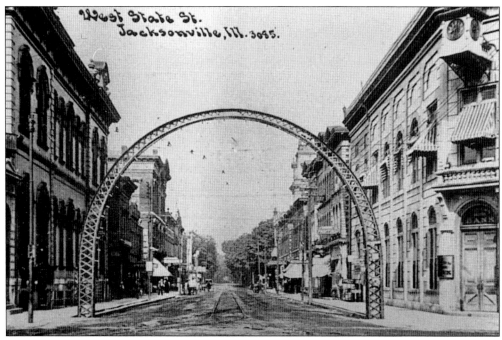

DOWNTOWN JACKSONVILLE AT THE TURN OF THE CENTURY. The square and the streets leading to it were the mall of the early 1900s. The trolley tracks ran through the arch, which was a memorial after the Spanish-American War. The dirt streets were dusty in the summer and mushy in the winter.

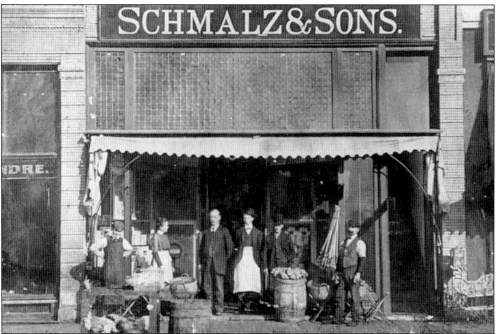

SCHMALZ AND SONS. This precursor of the supermarket was one of many groceries in the square shopping area. It sold goods inside and out and offered the very freshest poultry. Note the live chickens for sale.

96

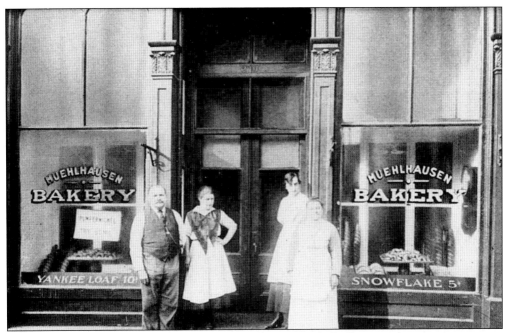

MUEHLHAUSEN BAKERY. The aroma from a bakery is like a whiff of heaven, drawing in customers who might want to buy the Yankee Loaf for 10¢ or a Snowflake for 5¢.

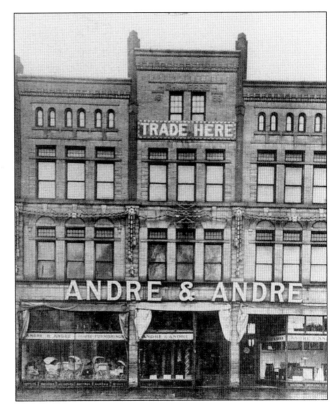

ANDRE AND ANDRE. At Andre and Andre, one was welcomed by the large TRADE HERE sign high atop the shop. There are baby carriages for sale in the window, and they had carpets, stoves, and ranges as well as chairs, lamps, and tables. Inside the store one whole room was devoted to the sale of rocking chairs.

THE JOURNAL-COURIER NEWSPAPER, AN OLD TRADITION. The Jacksonville *Journal-Courier* is the oldest, continuously published newspaper in the state of Illinois. It dates its history back to 1830 when it was called the *Western Observer*, established by James G. Edwards. The lettering above the door says Journal Office. Sammy Nichols, editor, is the first man in the second row standing. The child on the shoulders of his grandfather is Bill Fay.

WALTER H. MEYER, LINOTYPIST. In this photo, Walter H. Meyer works the old linotype machine at the Jacksonville *Journal-Courier*. He is remembered as a gentleman who took great pride in doing his work well.

HOCKENHULL, KING AND ELLIOTT BANK, 1866. Pictured here are Robert M. Hockenhull and his brother John N. Hockenhull on the front step of their bank in the 1890s. Edward Elliott was the president of the bank, which began in 1866 in the uncertain years following the Civil War. It joined the Ayers Bank, The Brown Bank, and the First National Bank of Jacksonville to offer banking services to the community.

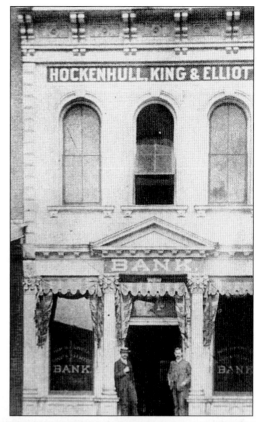

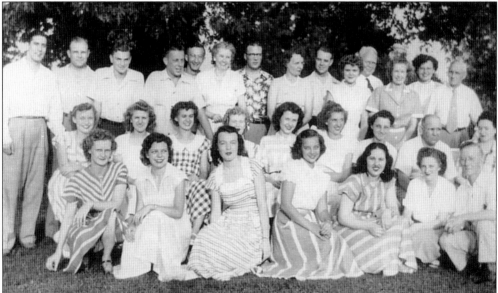

ELLIOTT STATE BANK STAFF IN 1949. In 1909, the Elliott State Bank became the new name of the old Hockenhull, King and Elliott Bank. Edward Elliott's son Frank continued to lead the bank until 1936. Through the years of the late 20th century, bank mergers have been popular, and the Elliott Bank is currently called the Mercantile Bank.

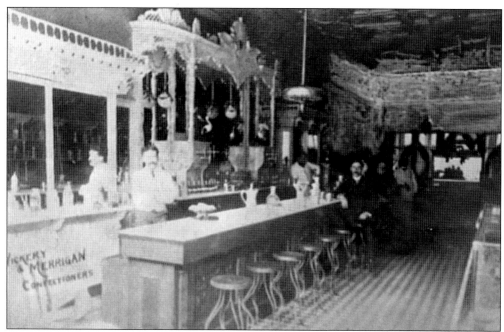

MERRIGAN'S ICE CREAM PARLOR. The turn of the century saw the rise of ice cream parlors due to modern refrigeration techniques. Merrigan's was a favorite ice cream parlor and lunch spot, at 227 West State. When this photo was taken, it was the Vickery and Merrigan Confectioners.

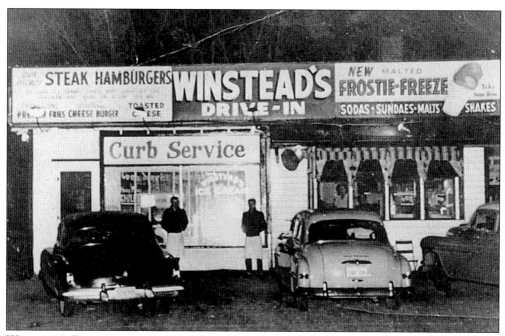

WINSTEAD'S DRIVE-IN. A popular, early drive-in restaurant was called Winstead's. Curb service was provided by handsome young men. Steak hamburgers were advertised as were toasted cheese sandwiches, Frostie-Freezes and sodas, sundaes, malts, and shakes. Later, car hops tended to be female, but here at Winstead's, curb service was offered by males in white aprons.

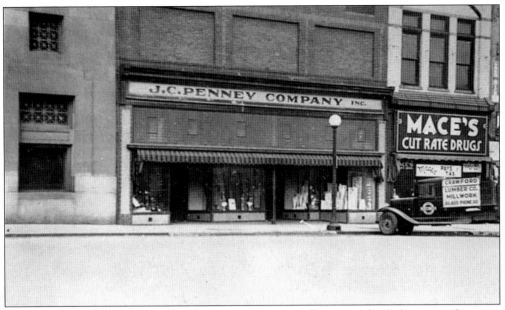

THE J.C. PENNEY STORE. The J.C. Penney store was on the west side of the square for many years. As a sign of the times, it is now located in the Lincoln Square Shopping Mall off Morton Avenue. The store continues its fine reputation of offering quality goods.

JAMES CASH PENNEY VISITED JACKSONVILLE. In the 1950s, Mr. Penney, the founder of the department store chain, visited Jacksonville. Here he is posing with Evelyn McCreery Mason, whose father was the store manager.

THE PRAIRIE PIONEERS. The radio station WLDS began operating on December 9, 1941, with Ken Lambert's words: "Good morning. This is WLDS, your Lincoln-Douglas Station." Pictured here are the Prairie Pioneers, a local musical group that broadcast a live program on WLDS from 1945 to 1955.

THE SPIRITUAL HARMONIZERS. The Spiritual Harmonizers performed live on Sundays with renditions of spirituals. They include: William Johnson, Baritone; Eugene Hayden, Baritone; Howard Reese, Bass; Milton McPike, Baritone; Elgin Welles, Tenor; and Homer Portee, Tenor. Listeners enjoyed hearing them on the radio, but also enjoyed hearing and seeing them in person.

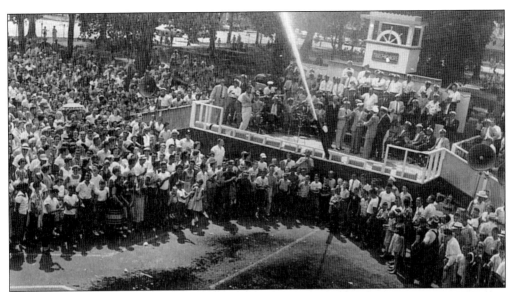

THIRST NO MORE, AUGUST 27, 1955. Jacksonville is far from a large river to use as a source of water supply. This was not a big problem early on, as wells and water towers did an adequate job for many years. But to attract big business to this land-locked area, a guaranteed water supply was imperative. The solution was to build the longest pipeline in the state of Illinois. It succeeded and industry has increased.

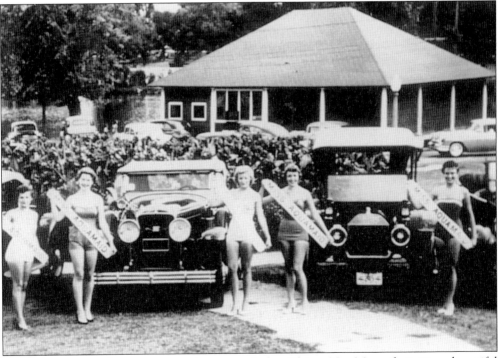

MISS AQUAMAID CONTESTANTS. As part of the Thirst No More festivities, beautiful aquamaids enlivened the events. Here, the maids posed in Nichols Park. They are, Shirley Spreen, Diana Dawdy, Ann Pearce (crowned Queen of the Aquamaids), Barbara Munk, and Marilyn Todd.

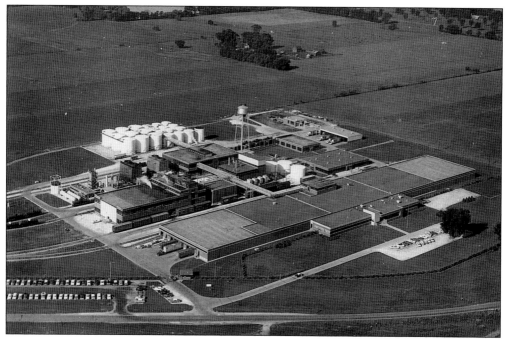

AERIAL VIEW OF THE A.C. HUMKO PLANT. This aerial view of the A.C. Humko plant on East Morton was taken in the mid-'50s, when it was Anderson Clayton. The guaranteed water supply offered by the water pipeline to the Illinois River encouraged plants such as this to locate in Jacksonville. Chiffon margarine was developed and produced here, as well as Seven Seas Salad dressing. Now known as the A.C. Humko plant, it produces edible oils and shortenings for retail, food service, and food ingredients.

THE TENNECO PLANT. The exterior of the huge Tenneco plant on East Morton gives some idea of the scale of the production going on inside. The plant produces plastic bags, grocery bags, and stretch film. Over a thousand Tenneco workers run the plant 24 hours a day, seven days a week. Their products are sold near and far under the trade names Hefty and One Zip.

Nine

MEDICAL TRADITIONS

Medical care in the Old Northwest was inconsistent, while illness and need were consistent. Cholera, malaria, childbearing, and injuries were all nursed at home. Early death was not all that unusual. In Jacksonville, many owed their health and literally their lives to a determined midwife fondly called Mother Carson. She and her husband Thomas ran the first inn/tavern and Thomas acted as the first jailer. Her successful career included attending to over 3,000 births in Jacksonville and beyond.

In 1843, Illinois College opened the first medical school in the state. It attracted successful, learned physicians as teachers, such as Dr. David Prince of Quincy. Two reasons suggest why it abruptly closed in 1848 when it seemed to be prospering. One reason is the perpetual lack of money to pay salaries at the college; the other is an apparent distrust in the community regarding the acquisition of cadavers for the anatomy labs. Stories of grave watchers assigned to guard recent burials imply the fear that the medical school did not get all their bodies from "abroad."

Yet quality medical care continued in Jacksonville for many years, in the form of small private hospitals. Two larger ones, Our Saviour and Passavant, merged into Passavant Hospital in 1968. Today, nursing is a course of study at MacMurray College.

And the tradition of excellent medical care continues today.

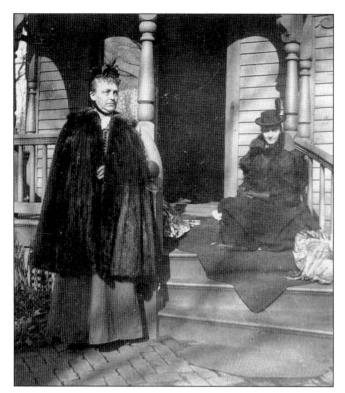

MABEL GOLTRA 1874–1965.
In the days before hospitals, babies were born at home. According to Mabel's autobiography, the respected, elderly Dr. Hiram K. Jones assisted in her arrival into this world. "I was a semi-still born child and my mother said it was only through the very skillful handling (which consisted of being banged against the headboard of the bed to make me breathe) of the elderly doctor that I made a safe landing."

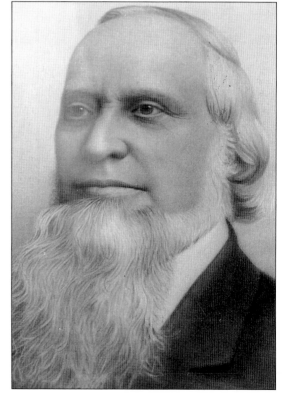

DR. WILLIAM A. PASSAVANT, D.D.,
FOUNDER OF PASSAVANT HOSPITAL.
Dr. William Passavant was a Lutheran minister who was deeply concerned with the orphaned, the homeless, and the sick who were poor. On a trip to Germany, he was impressed with an institution which had combined an orphanage, infant school, and hospital with the Mother House for Protestant Deaconesses. Establishing such facilities in the United States became his life work.

DEACONESSES AT PASSAVANT HOSPITAL ON EAST STATE STREET. Passavant Hospital was founded in 1875 through the generosity of Mrs. Elizabeth Ayers, who gave the property to Dr. William W.A. Passavant for an orphanage. It was decided that better use would be made of the property if it were to be a hospital instead. Dr. Passavant already had hospitals in Pittsburgh, Milwaukee, and Chicago, but he agreed with this change in plans.

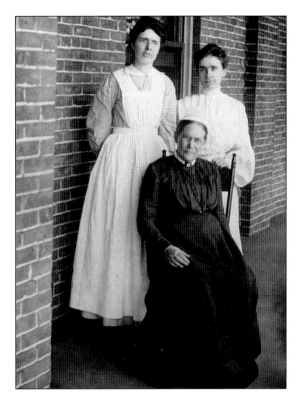

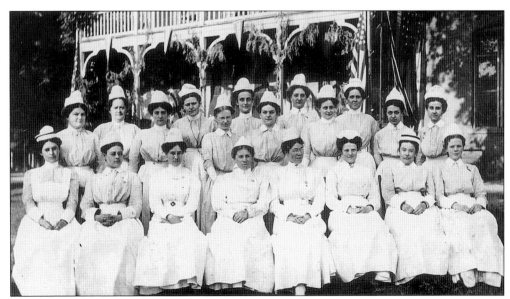

PASSAVANT HOSPITAL NURSES CLASS, JUNE 8, 1913. Dr. Passavant had been very impressed with the deaconesses he met in Germany on a visit there. So, a nursing school became a logical component of Passavant Hospital. Nursing as a course of study is currently offered at MacMurray College.

DR. KENNIEBREW IN HIS OFFICE. Dr. Alonzo H. Kenniebrew's private surgery was founded in 1909 in a six-room cottage with one trained nurse, one surgeon, three beds, an operating table, a few miscellaneous articles, a great determination, and the wide future. It grew commensurate with the expectations and soon had 33 rooms, laboratories, and two operating rooms, with seven nurses, three surgeons, and eight associate surgeons. In an address to the Illinois Medical Association, he said, "Prove that you possess superior ability and skill and regardless of your race, I assure you that the human thirst for all that is best will shower you with recognition and crowd the pathway to your office."

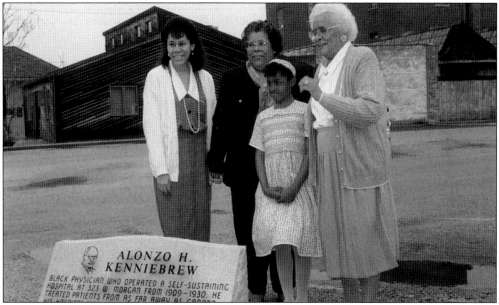

A TRIBUTE TO DR. KENNIEBREW. Dr. Kenniebrew's widow and family returned to Jacksonville to join in a tribute to their famous relative. Dr. Kenniebrew practiced in Jacksonville from 1909 to 1930. He trained surgeons here for service in WW I. He was later inducted into the Jacksonville Hall of Fame. "As physicians you must realize the fact that results of your work tell the people more about your skill and your ability than your sheep skin or social standing," began Dr. Kenniebrew to the Illinois Medical Association. His brochure from the early 1900s shows these results for all to see: 2557 cases and 25 deaths (less than one percent) and "these occurred in patients in dying state on entering and were never operated on."

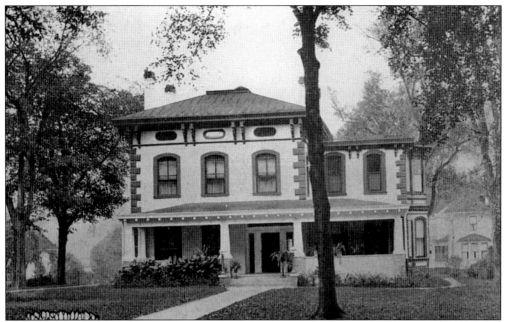

DR. DAY'S PRIVATE HOSPITAL. Dr. James Allmond Day founded his private hospital in a large home on West State Street in 1911. A number of private hospitals opened in Jacksonville in response to conditions in some of the wards of the large hospitals. Dr. Day's hospital specialized in the treatment of surgical and obstetrical cases. His brochure stressed the cleanliness of the hospital, by not admitting infectious medical diseases which might contaminate surgical patients.

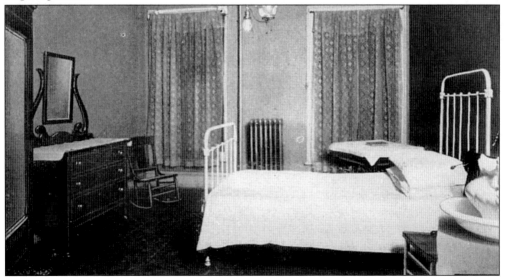

PRIVATE ROOMS WERE STANDARD. Dr. Day stressed the superiority of private rooms, as compared with the wards available in large hospital settings. The location of the hospital was important because "it is so situated that patients have the advantage of pure air, sunshine, and restful quietude, which are so necessary to their comfort, and are not subjected to the nerve-racking and worrisome noises, which unfortunately exist in the neighborhood of so many hospitals, such as the whistling of trains, the roar of heavy traffic, etc."

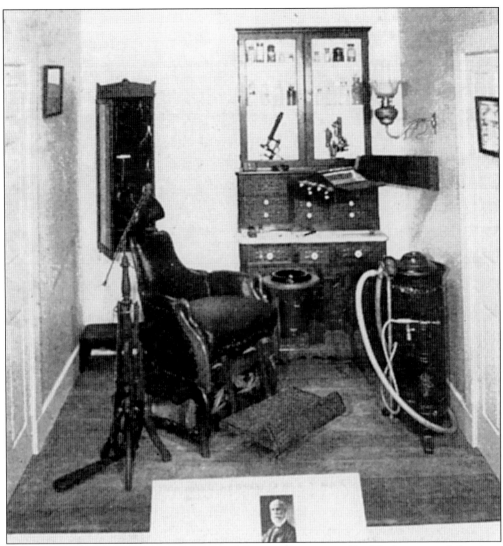

DR. GREENE VARDIMAN BLACK, FATHER OF MODERN DENTISTRY. Dr. Black practiced dentistry in Jacksonville from 1864 to 1896. He invented the formula for silver fillings, he designed the belt-driven dental drill, and he became the Dean of Northwestern Dental School. He wrote some of the first dental texts, which were later re-edited and published by his son. His Jacksonville office has been recreated in the Smithsonian Institution.

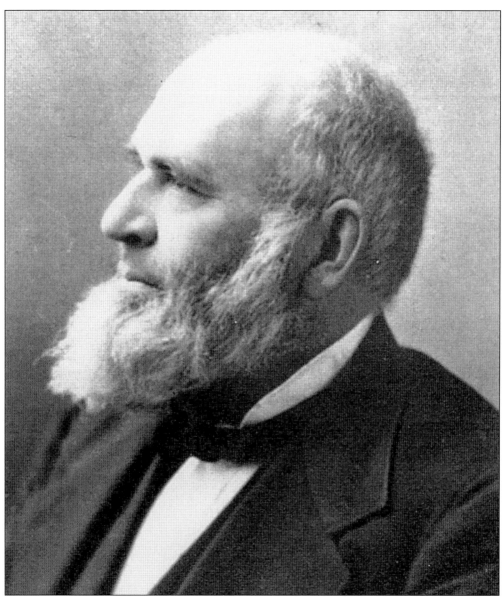

DR. DAVID PRINCE, (1816–1889), PIONEER IN PLASTIC AND ORTHOPEDIC SURGERY. Dr. David Prince was a physician, surgeon, and Professor of Anatomy and Surgery at the new Medical School at Illinois College in 1843. When the school of medicine closed its doors in 1848, Dr. Prince stayed in Jacksonville, and after the Civil War, he opened the Jacksonville Surgical Infirmary, the first private hospital in the city (1861). Dr. Prince came home from the war with a better understanding of anesthesia and antisepsis. He used a system of filtered air with air locks sealing off the operating rooms from other parts of the building. His infirmary specialized in surgery, nursing care, and physical therapy. His plastic surgery skill showed in that he invented a new method for restoring the lower lip and face.

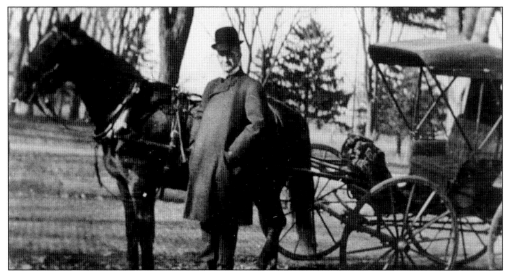

HOUSE CALLS IN THE HORSE AND BUGGY DAYS. Frank Parsons Norbury started his medical practice in Jacksonville in 1888. He traveled many miles in his horse and buggy making house calls. He was trained in Neurology and Psychiatry and worked at the State Hospital and Oaklawn before opening the Norbury Sanatorium in 1901. It served a need during the days when the State Hospital suffered from insufficient funds and general hospitals would not admit psychiatric patients. Three generations of Norbury doctors have dedicated their lives to helping the people of Jacksonville. Frank Garm Norbury and Frank Barnes Norbury continued the fine tradition begun by Frank Parsons Norbury. Together they provided over 100 years of medical service to others.

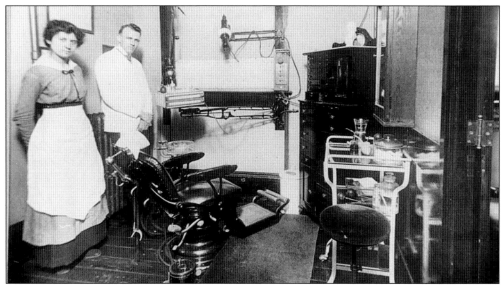

DOCTOR APPLEBEE'S OFFICE, ABOUT 1915. "Doc" Applebee's first office was on the north side of the square. A.B. Applebee was the son of a dentist who began the Jacksonville Savings and Loan when arthritis prevented him from continuing dentistry. Soon "Doc" joined his father in the savings and loan business, as did his son, Wadsworth ('Waddy'). The tradition continues in the family today, as "Doc's" grandson Andy is now chairman of the board of the Jacksonville Savings Bank, making four generations of family banking service.

Ten

THE TRADITIONS
CONTINUE

Jacksonville was more than once referred to as "The Athens of the West" due to the large number of institutions of higher learning that were established here. It would be hard to live here and not be aware of the town's rich, successful history. But a few less-than-successful moments passed also. For example, Jacksonville at one time hoped to be the Illinois state capital. At another time, Jacksonville was disappointed when Champaign was chosen to house the University of Illinois. But through all its ups and downs, and the comings and goings of a growing citizenry, Jacksonville has reserved a quiet charm and graceful dignity.

In 1999, the tradition of Chautauqua was once again a popular summer event. Though not on the grand scale of Chautauqua of old, when tents were pitched at Nichols Park and townsfolk camped out for several weeks, none the less, it was a week-long celebration of education and entertainment in a relaxed, picnic style. From the raising of the huge tent on the eve of the events, to the closing ceremonies, young and old alike were found enjoying the re-creation of a time gone by.

And so the traditions continue, changing a bit, as Jacksonville looks to the future.

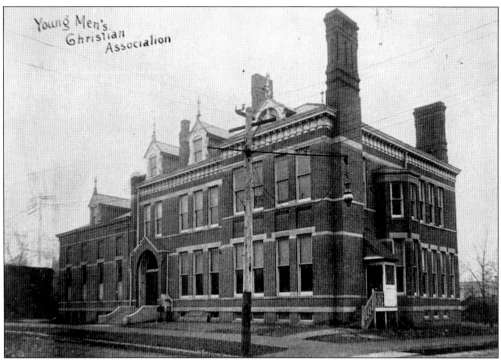

THE OLD YMCA, ESTABLISHED IN 1874. The YMCA was organized in 1874 with about 20 members. It didn't stay small for very long. It provided reading rooms, a soup kitchen, night school, and young people's meetings. It held the contents of the public library for several years.

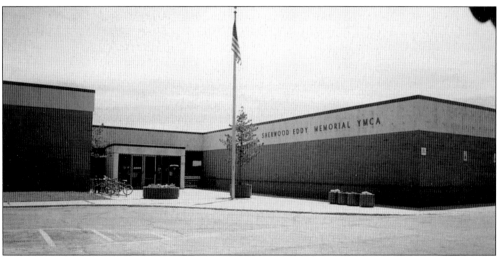

THE SHERWOOD EDDY MEMORIAL YMCA, 1968. The Sherwood Eddy Memorial YMCA was completed in 1968 for $900,000 on a 39-acre site north of Morton Avenue and west of Woodland Avenue. It features facilities for all ages, sizes, and preferences. Not content to offer only the usual programs, the Y provides after school programs for children, including foreign language classes.

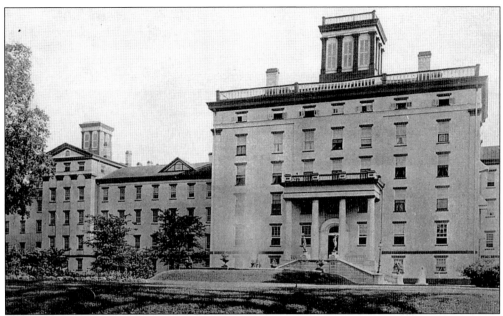

THE STATE HOSPITAL FOR THE INSANE. When Jacksonville acquired the State Hospital for the Insane, its services were much in demand. It was state-of-the-art in 1851 when the first building was ready, and many people were employed to build the buildings and staff them when they were finished. In the first year, 138 patients were treated. Soon it was the home for between 2,000 and 3,000 patients.

THE PATHWAY SCHOOL PLAYGROUND. Jacksonville has historically provided good care and opportunities for people with mental disabilities. Pathway School is just one example of the way that tradition is continuing into the 21st century. Pathway School began in the basement of the Congregational Church, and has expanded to include several buildings, group homes, and services for the needs of mentally handicapped people of many ages and skill levels.

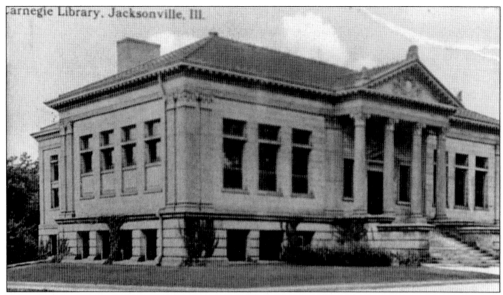

THE JACKSONVILLE PUBLIC LIBRARY, 1903. The Jacksonville Library Association began in January 1871, with a dues-paying membership. A free reading room was opened to non-members in 1874. The library was dependent on donations, and locations were changed several times, including the courthouse and the YMCA building in 1880. Andrew Carnegie, philanthropist, offered to pay for the building of the library if the city council would provide the site and maintain it.

THE LIBRARY ADDITION, 1995. The public library had seen constant use and increased patronage over the years to the point where major renovation was needed. The library also needed to become more accessible, and so a campaign began to update, add to, and enhance the existing library. The addition is harmonious with the older part of the building, and Andrew Carnegie would be pleased with the results. Efforts are made to provide assistance to people with hearing and visual limitations by a caring staff. Computers are on site and a large collection of books on tape are well used by the community.

THE OLD WILLIAMSON FUNERAL HOME. When C.E. Williamson founded the Williamson Funeral Home in 1926, most families were used to the tradition of caring for the deceased at home. As it became more common to use a funeral home, the emphasis was on keeping the feeling of being at home. Since C. E. Williamson and his wife really did live above their funeral parlor, they honestly used the fitting advertising slogan, *Always At Home*. The old boardinghouse turned funeral home is now used by the Jacksonville Theater Guild.

THE NEW WILLIAMSON FUNERAL HOME. In 1998, the new Williamson Funeral Home was built on South Lincoln Avenue. It is owned by Terry and Mary Beth Airsman. This state-of-the-art funeral home was built from the ground up as a funeral home with attention to many special needs. Closed circuit TV, a large garage, adequate parking, and even a children's play room are all thoughtfully planned to meet the needs of grieving families.

117

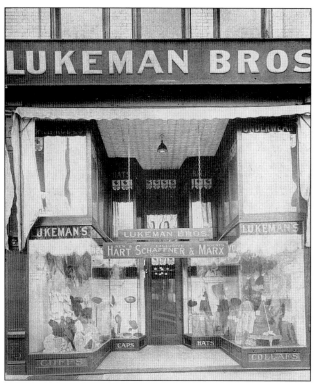

LUKEMAN'S CLOTHING STORE, ON THE OLD SQUARE. In 1910 Clarence and George Lukeman took their retail experience, gained working for the Myers Brothers Stores in Springfield and Jacksonville, and began their own men's clothing store on the square.

LUKEMAN'S CLOTHING STORE, LINCOLN SQUARE SHOPPING MALL. Today the tradition of quality clothing continues with their motto, *Quality merchandise and service at a fair price.* The present owner is Jack Lukeman, third generation of Lukeman family members serving the community.

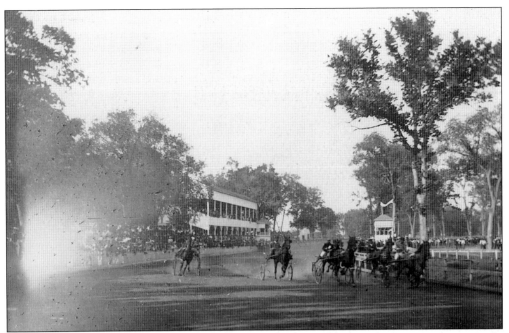

THE MORGAN COUNTY FAIRGROUNDS. When the fairgrounds were built, the site was purposely chosen way out to the west of town, easily accessible to farmers. Ulysses S. Grant camped his army at the fairgrounds on July 4, 1861, as they began their campaign in the Civil War. Horse races were popular events, and the grounds served the needs of summer fair-goers.

THE FAIRGROUNDS TODAY. The County Fair is still a big event at the Fairgrounds, but the grounds also provide the race track for car racing fans. On summertime Friday nights, the parking lots are filled, the stands are overflowing, and the tops of cars and vans become makeshift bleachers as fans of sprint car racing gather to cheer their favorite car or driver.

BENTON AND ASSOCIATES, INC., 1970. The self-made man, who finds his place in life and is successful, is not confined to the last century. Starting out in a basement may epitomize the "bootstraps" theory of rising in the business world, and that is exactly how Benton and Associates began. When Robert Benton accepted an engineering consulting job with the town of Winchester, he dreamed that it could lead into a business of his own. Robert was joined out in the field at Winchester by his 12-year-old son Reggie. And by the time the project was finished, there was a hopeful future looming. Seen here is the Benton and Associates office at 505 East State Street in 1970.

BENTON AND ASSOCIATES, INC., 1999. Milestones were passed as the years went by. The offices grew small as the staff grew larger. So it is that today the firm of Benton and Associates is housed in a 9,300-square-foot building in which the owners, Robert H. Benton, Paul L. Hansen, Richard G. Rawlings, and Reginald Benton continue with clients in fields such as Industry, Government, Drainage Districts, and Water Treatment Plants.

120

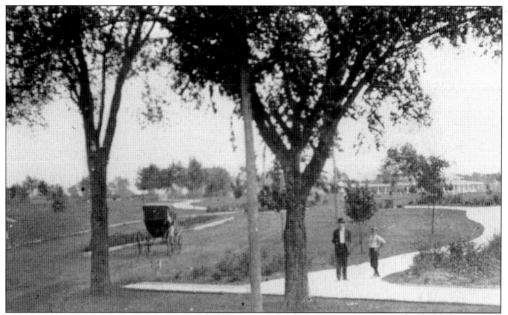

NICHOLS PARK THEN. Sammy Nichols (1844–1927) couldn't do enough for the town he loved and the children he cared about. Sammy never forgot the poverty in which he was raised, and tradition tells of him treating dozens of children to Christmas gifts, ball games, and even a train trip to The Louisiana Exposition in St. Louis.

NICHOLS PARK TODAY. In 1903, Sammy Nichols donated $10,000 to buy a park, now named in his honor. Each fall, he had a burgoo party, a tradition children loved. He had no children of his own, so he, in essence, adopted the children of Jacksonville. A pool, a golf course, and a great pavilion grace the Nichols Park of today.

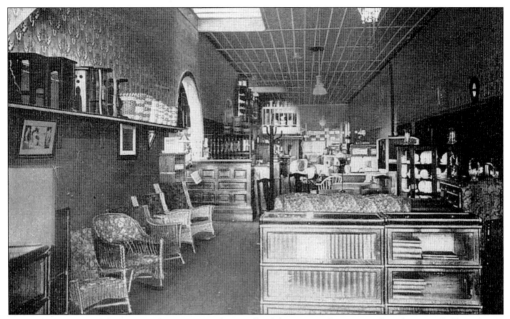

SHOPPING THEN. The Town Square was the mall of days gone by. It was bustling with businesses that overflowed the square onto the streets leading to the square. Shopping for groceries, bakery goods, clothing, and furniture was easily accomplished as all the stores were within close proximity. On the east side of the square, the Johnson, Hackett & Guthrie store offered furniture and more.

SHOPPING NOW. Morton Avenue offers the shoppers of today easy accessibility for those with cars, vans, and pick up trucks. Many small malls fan off "The Strip" to entice shoppers to pull in and shop. The distance between the stores is far enough to necessitate cars. The car-convenient shopping strip of today leaves some nostalgic for the old square, and attempts are underway to increase the usability of the square today.

PASSAVANT MEMORIAL HOSPITAL ON EAST STATE STREET. Berean College occupied property on East State Street and was purchased by Mrs. Eliza Ayers. When there was a fire at the School for the Blind, Mrs. Ayers quickly offered the students space for the continuation of classes. Then, Mrs. Ayers offered the site for Dr. Passavant's intended orphanage. When that endeavor didn't pan out, the site became Passavant Hospital.

THE NEW PASSAVANT HOSPITAL ON WALNUT STREET. The new hospital, located on the northwest part of town since 1953, has had several new additions, and much updating making it the modern facility that it is today. It is a 211-bed hospital with a Level II trauma facility. The Lifeline program allows people to remain at home with a higher measure of assurance. Community outreach through seminars, support groups, and general health education programming increases the community's awareness of health issues.

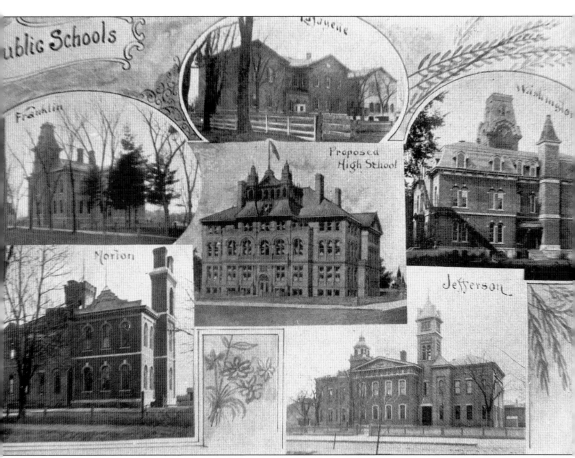

FIRST FREE HIGH SCHOOL IN ILLINOIS, 1851. In 1851, the West Jacksonville School District established graded classes and included studies as far as the college grades. In 1859, Newton Bateman, longtime friend of education, became superintendent of Public Instruction for the state of Illinois. In Springfield, Mr. Bateman had his office adjoining that of Lincoln and Herndon. Lincoln called Bateman "Little School Master" and spent much time with Mr. Bateman and his books. Jacksonville High School opened in 1867.

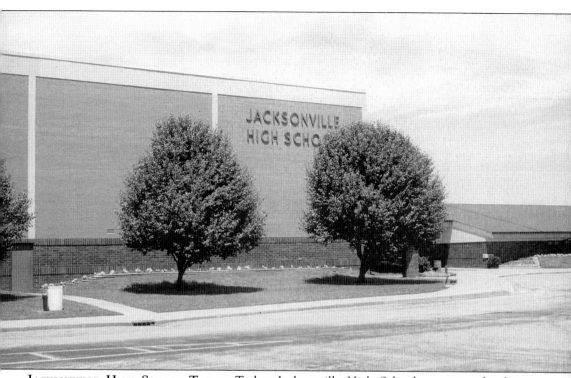

JACKSONVILLE HIGH SCHOOL TODAY. Today, Jacksonville High School continues the fine tradition of excellence in education offering the students of tomorrow high caliber educators who teach the full range of classes normally offered in high schools, and in addition, the school offers vocational training, work study programs, sign language, theatrical and musical productions, and band and orchestra. Jacksonville High even has a planetarium!

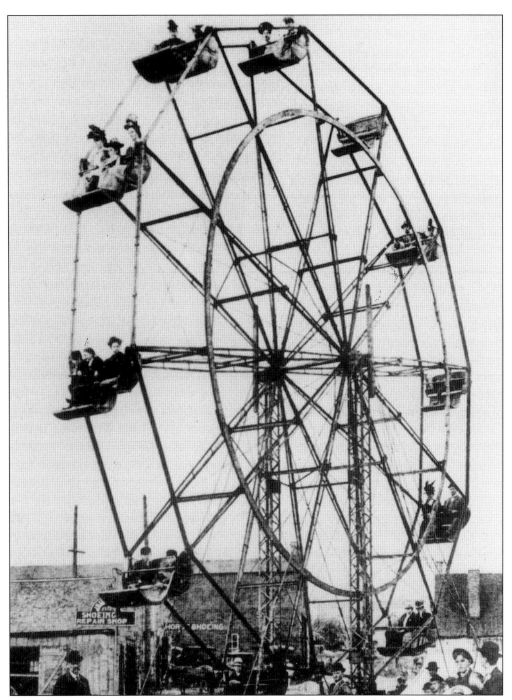

THE FERRIS WHEEL OF YESTERYEAR. When William E. Sullivan visited the World's Columbian Exposition in 1893, he came home with an idea of how to improve upon the HUGE Ferris wheel he had seen there. The wheel in Chicago was the largest ever built and had 36 bus-sized cars that each held 60 passengers! Sullivan was familiar with steel and made a model of a smaller more portable wheel. The original Big Eli, pictured here in 1900, now stands in front of the Eli Bridge Company.

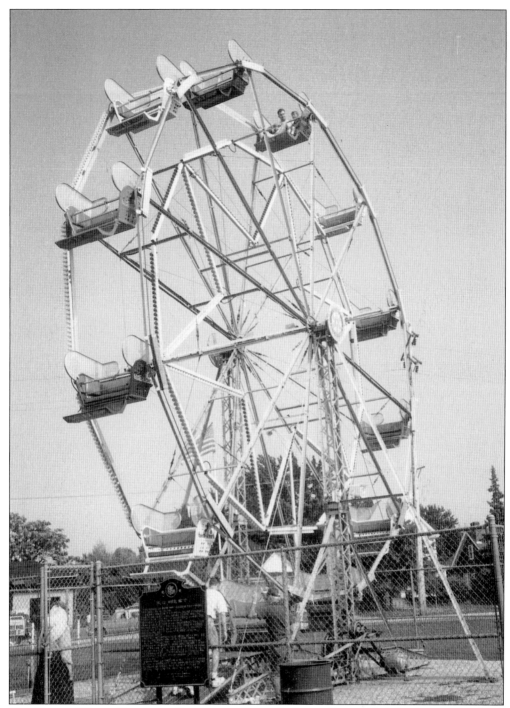

THE FERRIS WHEEL TODAY IN COMMUNITY PARK. Jacksonville wouldn't be the same without Big Eli's colorful lights offering its traditional welcome to Jacksonville. Other rides are also built here now, but the tradition of Big Eli continues alive and well in Jacksonville with #17 running every Sunday afternoon all summer in Community Park for the pleasure, and nostalgia, of young and old alike.

CHAUTAUQUA OF OLD. "Culture under canvas" came to the prairies with the Chautauqua movement in the early 1900s. Chautauqua is actually the name of a lake in the western part of New York where the Chautauqua movement began. It offered traveling educational opportunities in a relaxed picnic-style setting. People would set up camp in Nichols Park for the weeks Chautauqua was in town. Many dressed up for events at Chautauqua, as these young women demonstrate.

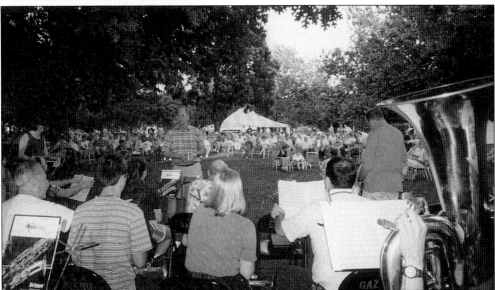

CHAUTAUQUA, JULY 1999. The return of a modified Chautauqua enlivened Community Park for a week in July, offering education and entertainment. The Heartland Chautauqua scholars portrayed General William Tecumseh Sherman, Sojourner Truth, Elizabeth Van Lew, Louisa May Alcott, and A.A. Burleigh.

At the tent raising and throughout the week-long event, great enthusiasm was shown for the local entertainment and the traveling educators. A good time was had by all as another tradition continues.